MAGNUM LANDSCAPE

Phaidon Press Limited
Regent's Wharf
All Saints Street
London N1 9PA

First published 1996
© 1996 Éditions Plume, Paris
English edition © 1996 Phaidon Press Limited
Reprinted 1997, 1998, 2000
Reprinted in paperback 2005, 2008, 2012
Photographs © Magnum

A CIP catalogue record for this book is available from the British Library

ISBN 978 0 7148 4522 7

Printed in China

Contents

Foreword

In the old days we - or our photographer surrogates - thought of ourselves in transit along sharply receding roads moving towards far horizons. They were, though, punctuated roads to be taken at walking pace past welcoming doorways in the streets of small towns. There was a goal, plainly stated, but it was the progress with its distractions which mattered. Deep space still exists in these landscapes of the 1970s and after, but it is a space often to be abruptly traversed towards some unimaginable destination. Formerly, too, the horizon drifted, as leisurely in its undulations as the road, but these more recent horizons cut across the scene intent on other business; and they are markers, too, of the earth's edges in relation to the great beyond. Thus defined as an incidental, humanity is no longer entirely at home.

The great space missions of the 1960s altered our perceptions of landscape irrevocably, for they familiarized us with news of the earth as Elsewhere, or as another planet rising and setting with planetary destinies. By enlarging our sense of space and time, the missions with their photographers made it possible - or just easier - to imagine the earth before habitation or once more abandoned under the trodden moondust of 20 July 1969. We were no longer to be so safely at home among nature's objects which we had put to our own uses: all those rocks, trees and rivers of poetry and theology which had long been part of the moral landscape. We had, after all, been pilgrims on a track leading past precipices and through forests. Nature stood as a warning, but it had also offered shelter.

From the 1960s onwards, however, we were invited to think of ourselves rather as short-term visitors to a site changing under our feet, and largely indifferent to our presence. Probably to save face, we claimed a negative responsibility for the deadening of the planet. That tactic at least implicated us in the greater drama, even if only as heedless players, assistants in our own downfall.

Familiarity with the idea of the planet as Elsewhere invited us to enter into the game of 'as if. In the 1920s we had wondered what it would be like to inhabit a perfected foreseeable future - not far off, if the blueprints were to be believed. Landscape, as envisaged under those Utopian terms, would be subdued; it would either be a managed adjunct to the city supervised from the air or it would be a homely world of vignettes seen selectively from the motorway. The first atomic explosion, at the Trinity site in New Mexico on 16 July 1945, began to dislodge that view, in advance of the spacement of the 1960s. What would it be like, the new turn of mind suggested, if there were to be no survivors or very few? How would it be to have to forage in the ruins of cities, under weather systems grown inhospitable? What would become of us, on foot in the wreckage without civilized amenities? Photographers, engrossed by the new narrative, turned their attention to survivors: cyclists making do among the ruins, solitaries lost in the woods or fleeing the city, or at the wheel of the last car in a landscape gone over to desert.

It would be an adventure, of course, to be among the survivors, and Magnum's is an adventure photography. Think of Magnum's history. It was set up in 1947 in the shadow of totalitarianism and with individual experience in mind. The overbearing regimes came and went, and although the new idea of planet earth might never have been as oppressive, it was - with all that talk of light years - indifferent to the small change of our own lives. The primary artists of this new creation were groups of operatives managing equipment on a vast scale, and they were known mainly through acronyms: NASA being the best-known. Magnum's strategy has been to recuperate all this enhanced and impersonal imagery of galaxies wheeling, and of the earth grown cold, hot or inhospitable, and to place it within range of imaginations nourished, as always, by whatever comes to hand - the tactics of *arte povera*, that is, put to use on the great themes of the moment.

Ian Jeffrey

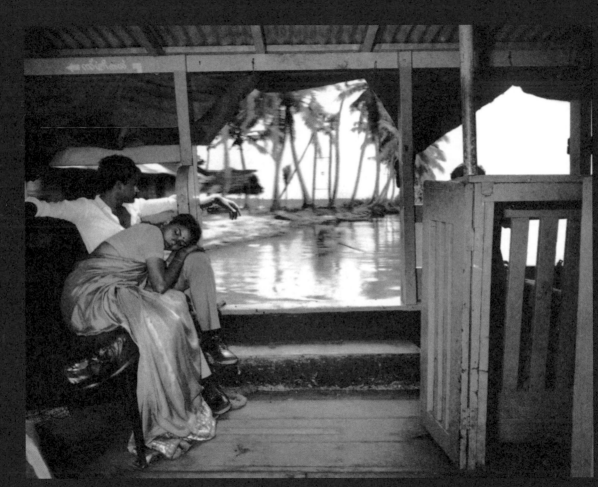

Carl De Keyzer - Alleppey, Kerala, India, 1987

-1-
Viewers of Landscape

Each landscape is formed by the point of view of the spectator; it is a spiritual experience, the reflection of a culture. In a sense, therefore, the photographer first has to make a portrait of the people who muse over the landscape they behold. In thus placing himself behind them, he expresses both complicity with the natives and irony towards the invaders. 'In the Middle Ages, people were tourists because of their religion; today, they are tourists because tourism is their religion.' Robert Runcie, Archbishop of Canterbury, 1988.

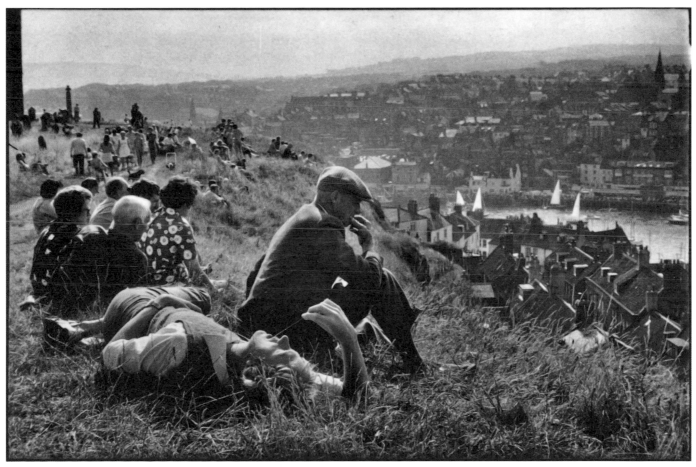

Ian Berry-Sunday afternoon, Whitby, England, 1974

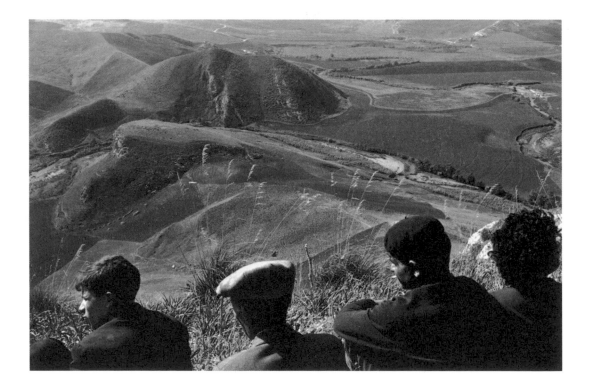

Ferdinando Scianna – Roccamena,Sicily, 1964

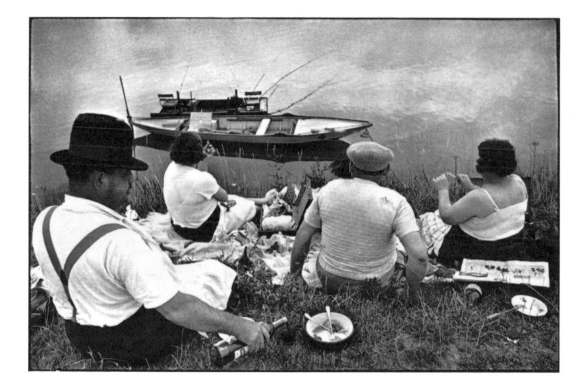

Henri Cartier-Bresson – Sunday by the River Marne, France, 1938

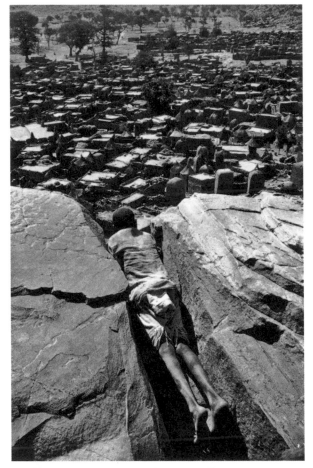

John Vink – The village at the foot of a cliff, Songo, Mali, 1986

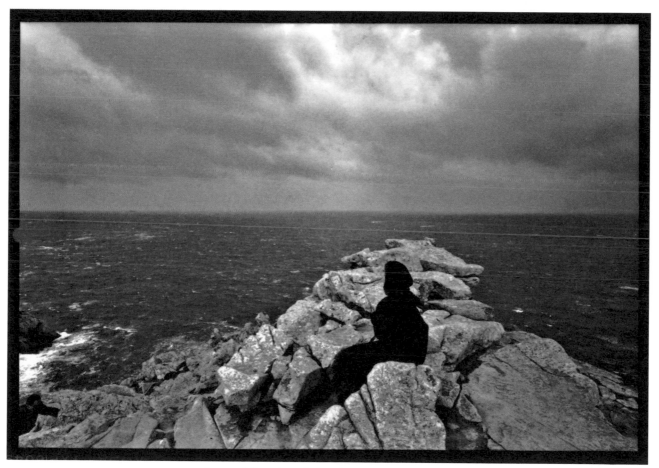

Raymond Depardon – Pointe du Raz, France, 1991

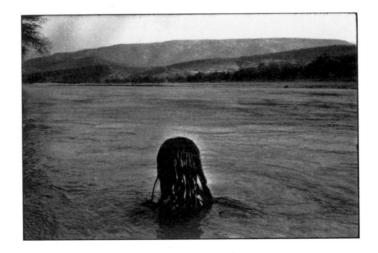

Abbas – San Augustin de Oapan, Mexico, 1985

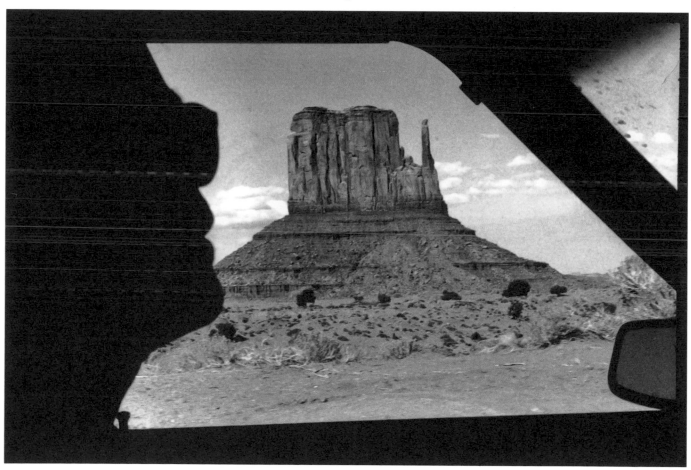

Raymond Depardon - Monument VaHey, Utah, USA, 1982

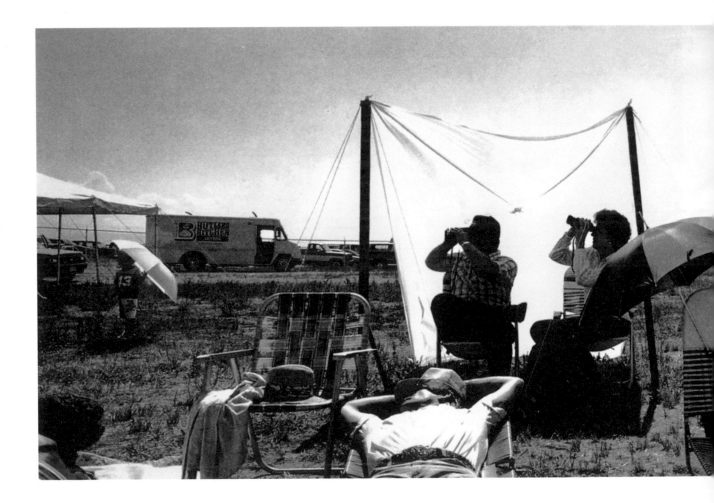

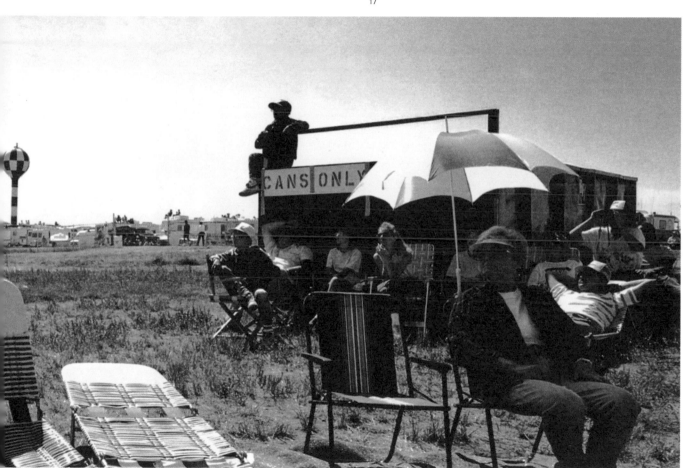

Carl De Keyzer - Air show, US Air Force Academy, USA, 1990

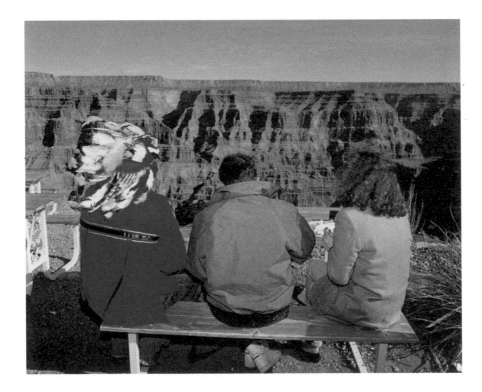

Martin Parr - Grand Canyon, Arizona, USA, 1995

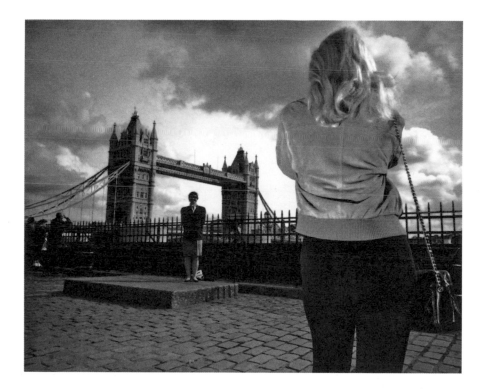

Carl De Keyzer - London, England, 1993

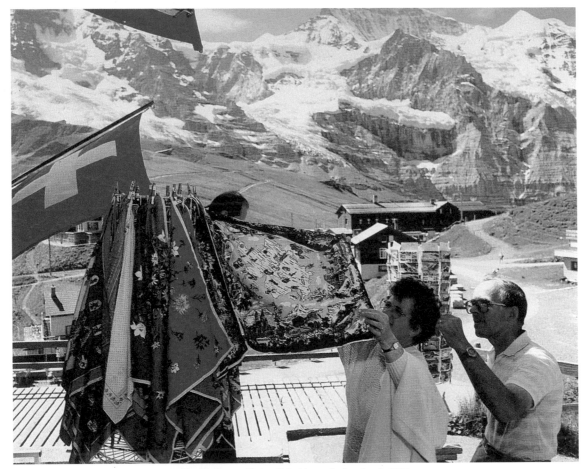

Martin Parr - Kleine Scheidegg, Switzerland, 1991

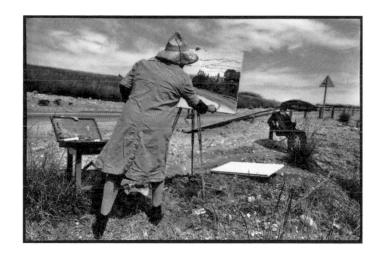

René Burri - Israel, 1973

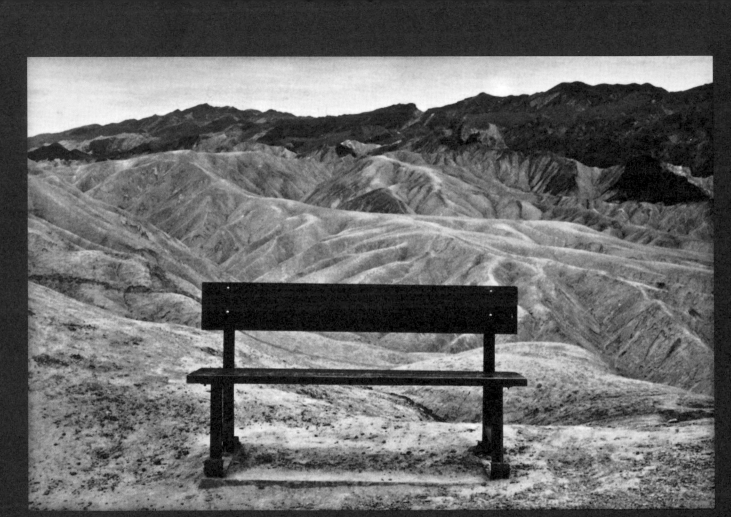

Raymond Depardon - Arizona, USA, 1982

-2-
Landscapes presented

The yearning to travel, to discover a place and the secret of its beauty, is reinforced through the contemplation of photographs - as if photography has invented the American West, the Alps, the Nile, Surrey or New York. The lover of landscape owes this emotional thrill to the eye of the artist who composes these 'photographic surfaces'. 'Some way within the limits of the stretch of landscape, points of light like the topaz gleamed. The air increased in transparency with the lapse of minutes... It was Christminster, unquestionably; either directly seen, or miraged in the peculiar atmosphere.' Thomas Hardy, *Jude the Obsure*, 1896.

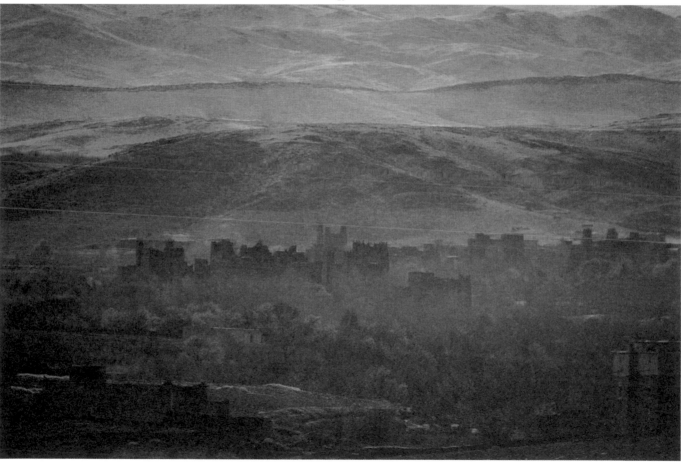

Bruno Barbey - Dades Valley, Kelaa des Mgnoua, Morocco, 1972

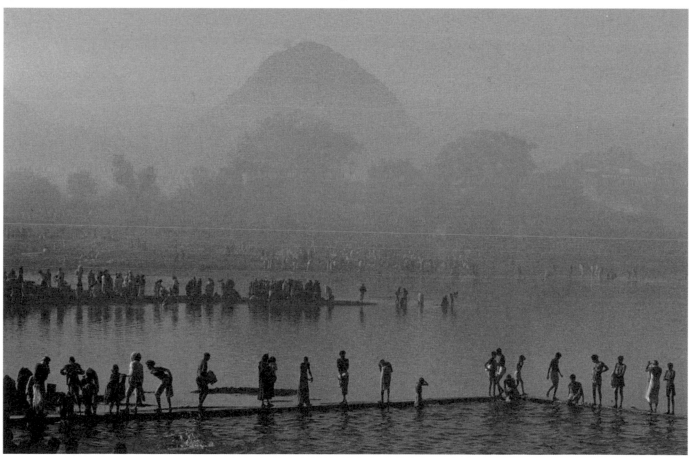

Bruno Barbey - Pushkar, Rajasthan, India, 1975

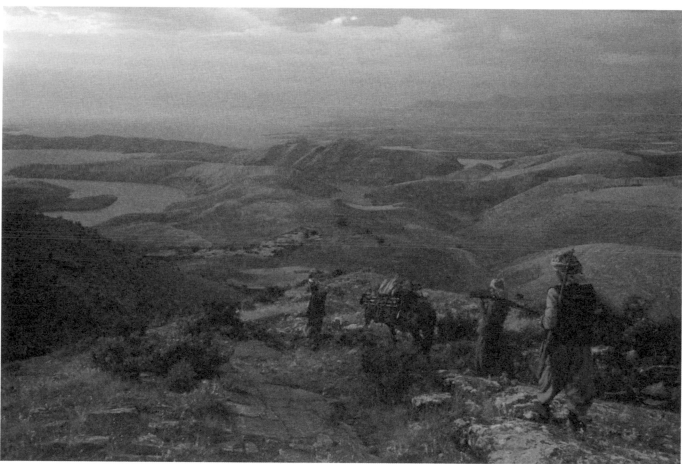

Bruno Barbey - Kurdistan, Iraq, 1974

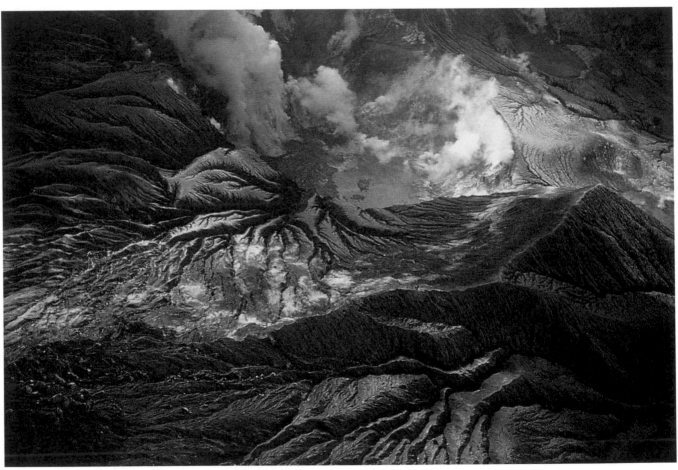

Ernst Haas - Volcano, Surtsey, Iceland, 1965

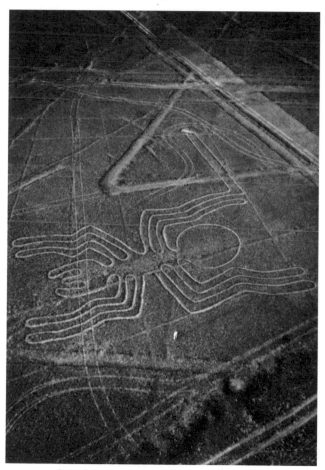

Cornell Capa - Nazca land drawing, Peru, 1963

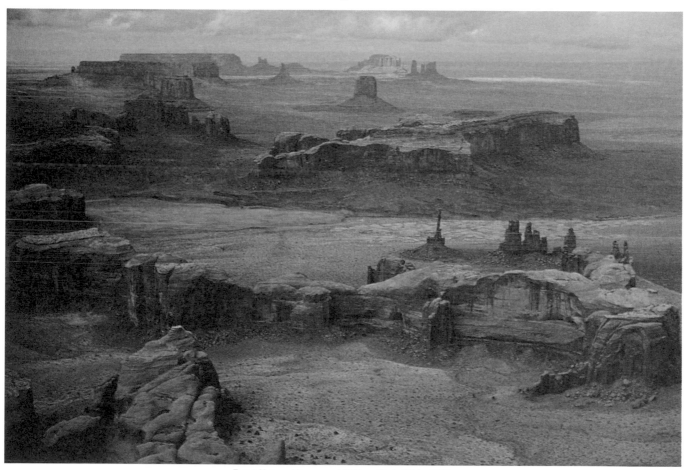

Ernst Haas - Monument Valley, Utah, USA, 1962

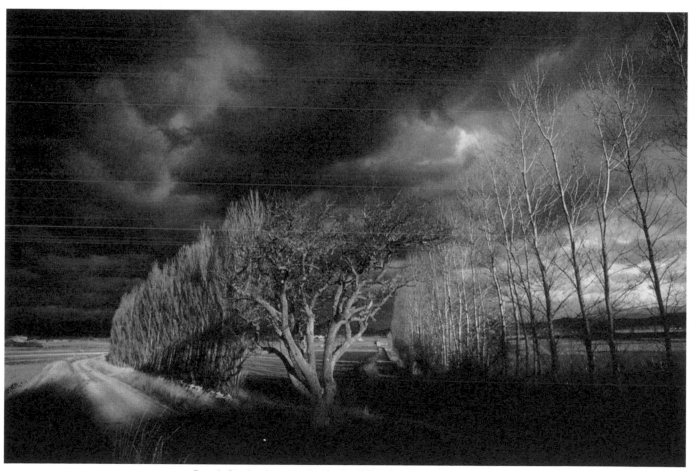

Dennis Stock - Storm in the Gordes Valley, Provence, France, 1982

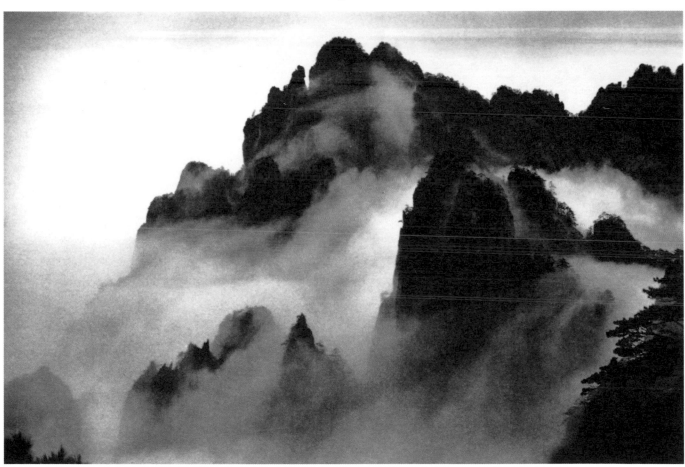

Marc Riboud - Huang-Shan, China, 1983

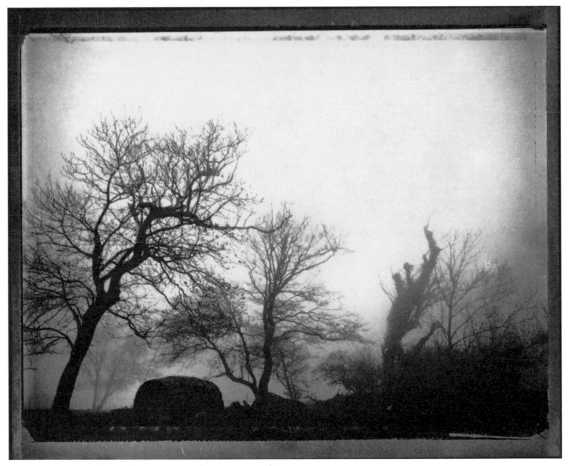

Gueorgui Pinkhassov - Pays de Caux, Normandy, France, 1993

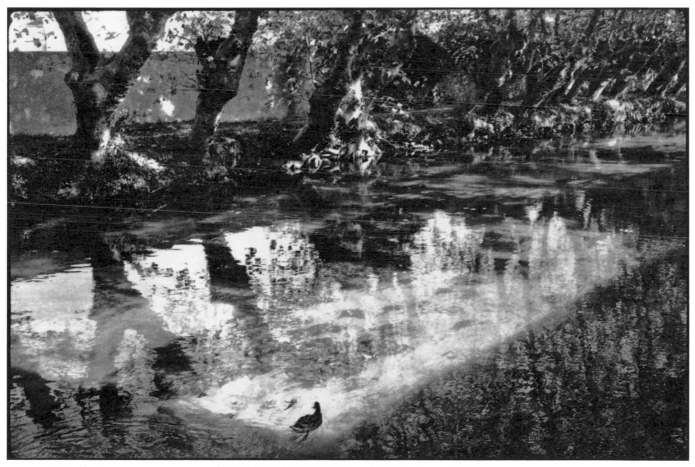

Henri Cartier-Bresson - L'Isle sur la Sorgue, France, 1988

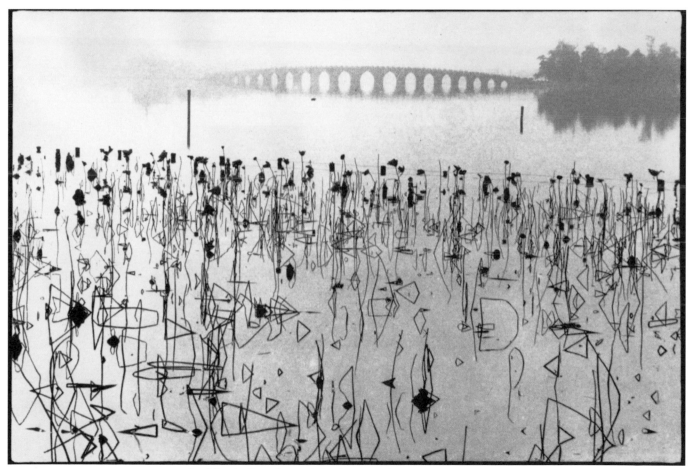

René Burri - Kun Ming Hu Lake, Summer Palace, Beijing, China, 1964

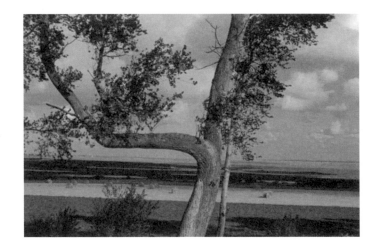

Harry Gruyaert – Baie de la Somme, France, 1991

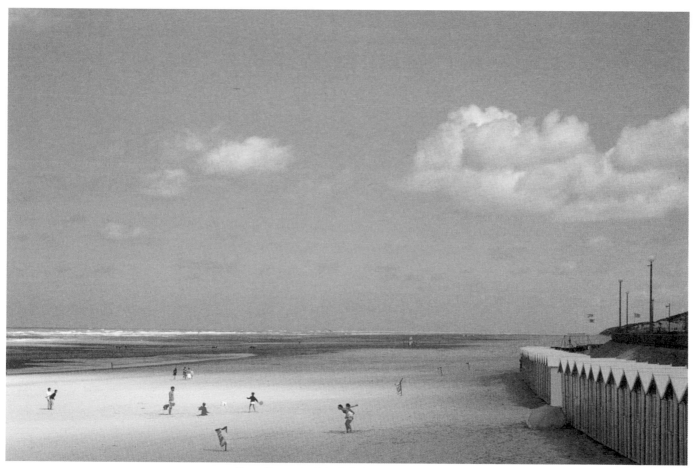

Harry Gruyaert - Baie de la Somme, France, 1991

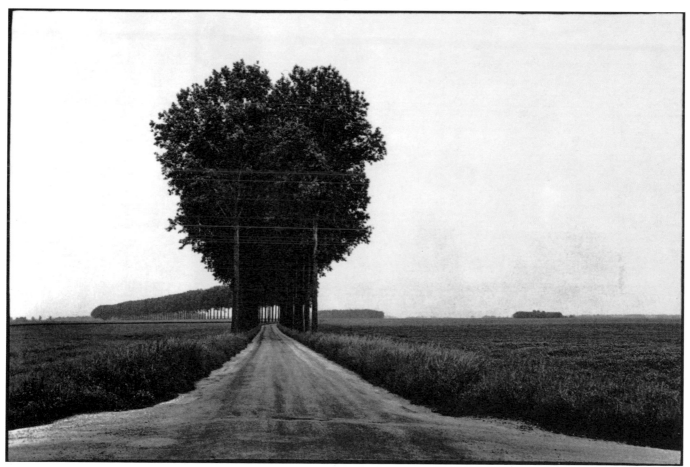

Henri Cartier – Bresson - Brie, France, 1983

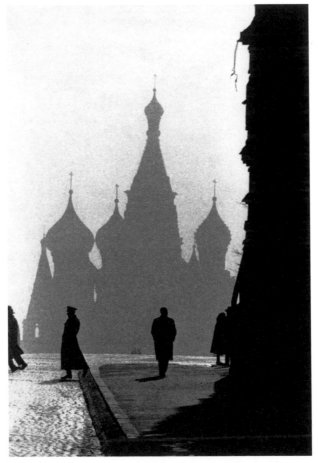

Burt Glinn - Cathedral of St Basil, Moscow, Russia, 1961

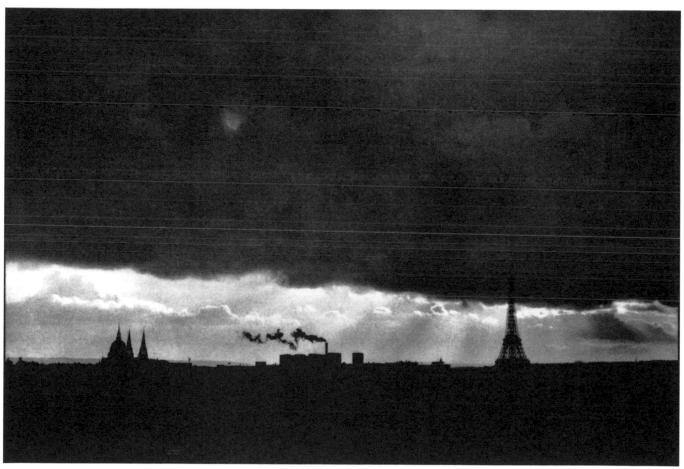

Henri Cartier – Bresson - Paris, France, 1983

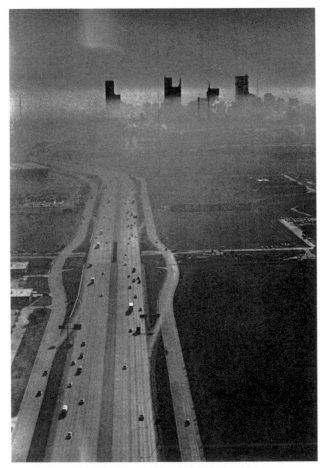

Elliott Erwitt - Dallas, Texas, USA, 1963

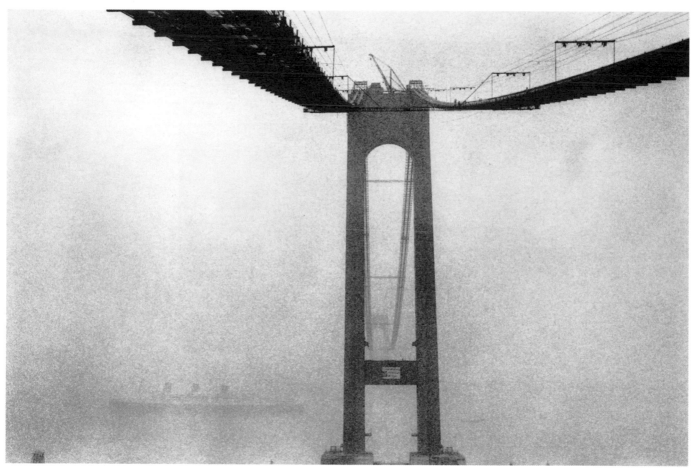

Bruce Davidson - The Verrazano Bridge and the Queen Mary, New York, USA, 1963

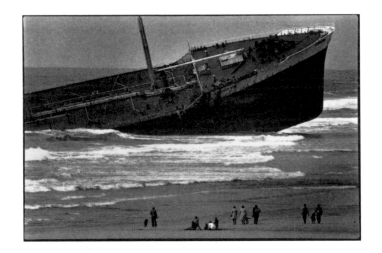

Jean Gaumy - Wreck of the Apollonian Wave, Aquitaine, France, 1978

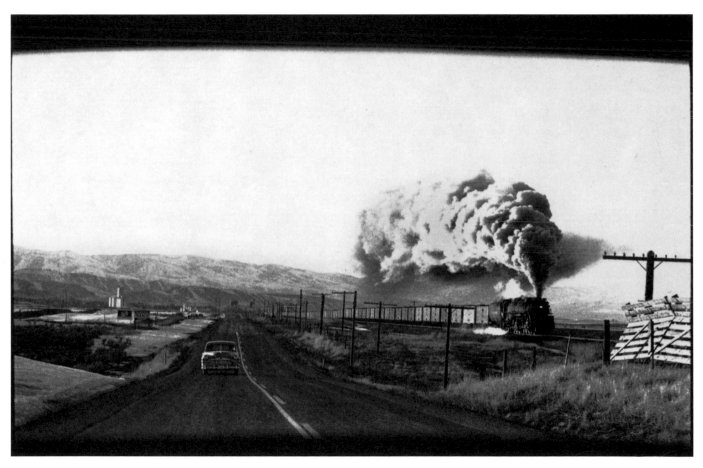

Elliott Erwitt - View from a car, Wyoming, USA, 1954

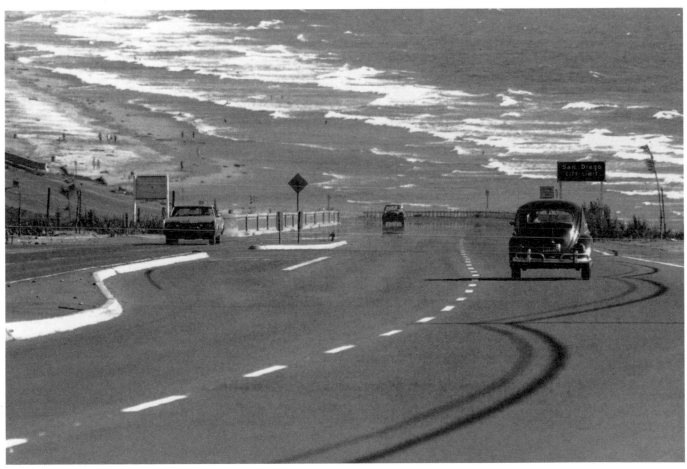

Dennis Stock - San Diego, USA, 1968

René Burri – USA, 1980

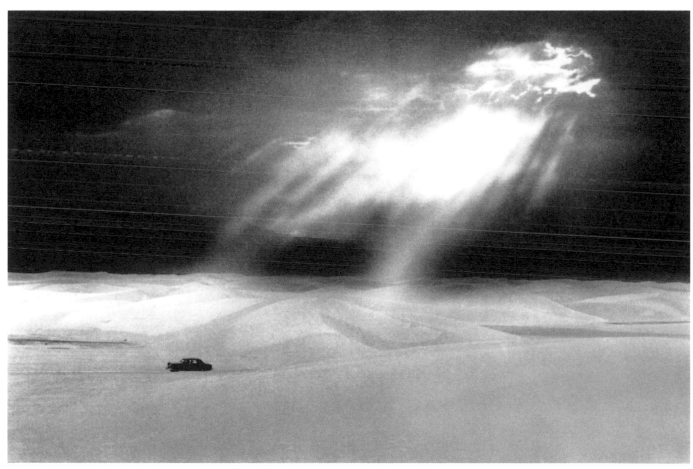

Ernst Haas - White Sands, New Mexico, USA, 1952

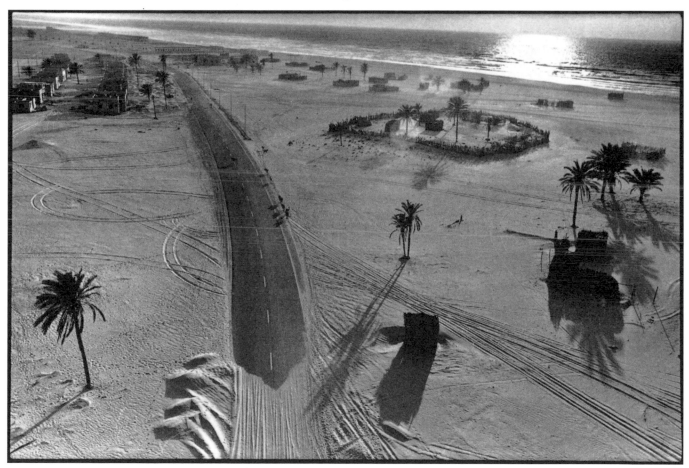

René Burri - Abu Dhabi, United Arab Emirates, 1975

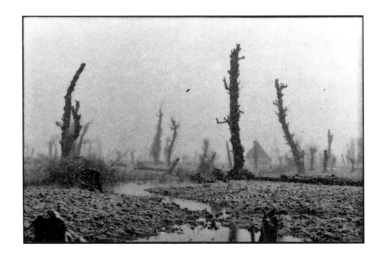

Inge Morath - Near the Caspian Sea, Iran, 1956

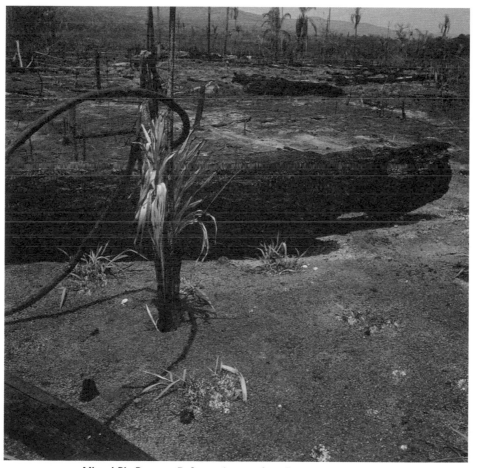

Miguel Rio Branco - Deforestation, southern Para state, Brazil, 1992

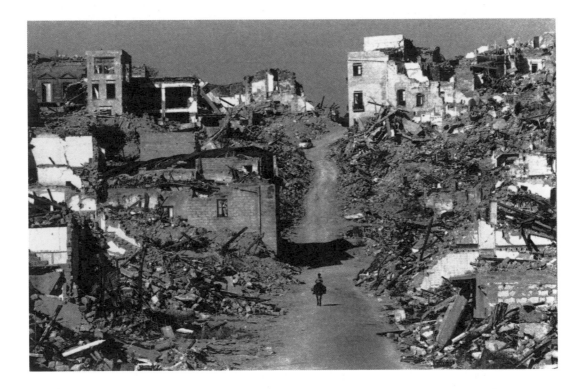

Ferdinando Scianna - Montenago after an earthquake, Sicily, 1969

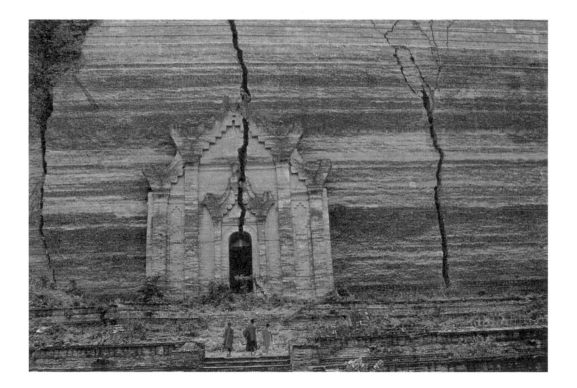

Steve McCurry - Pagoda after an earthquake, Mingun, Myanmar, Burma, 1994

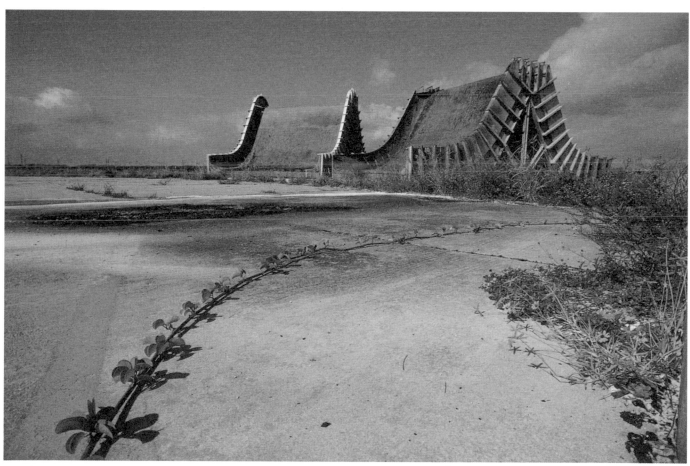

René Burri - Disused launch pads, Cape Canaveral, USA, 1978

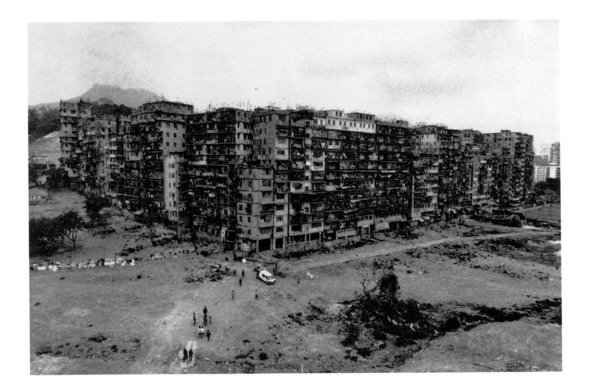

Patrick Zachmann - The Walled City, Hong Kong, 1987

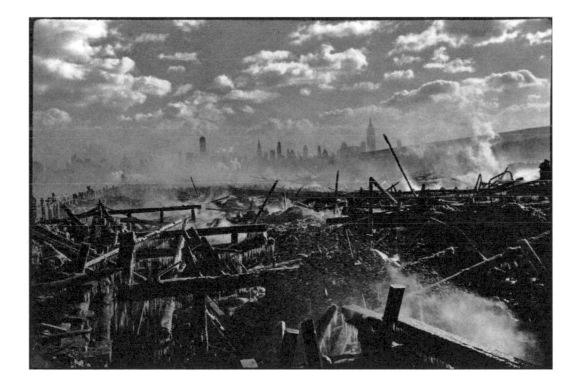

Henri Cartier – Bresson - Fire at Hoboken, New York, USA, 1946

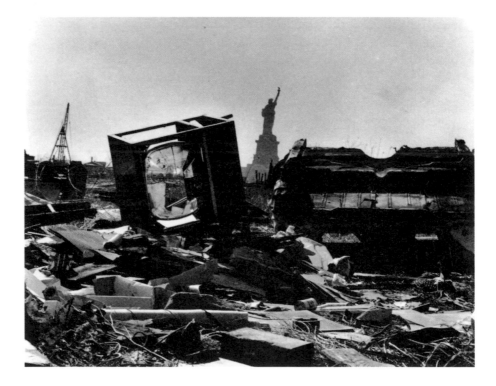

Bruce Davidson - The Statue of Liberty seen from Caven Point, New Jersey, USA, 1969

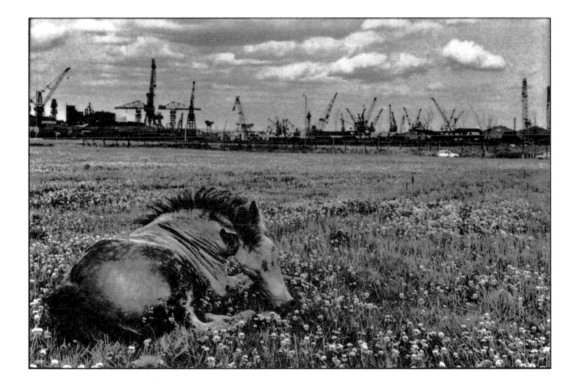

Martine Franck - Newcastle-on-Tyne, England, 1978

Bruce Davidson – Coney Island, Brooklyn, USA, 1966

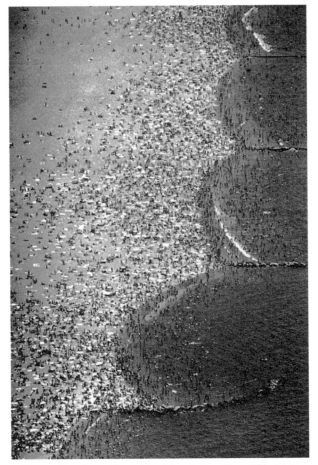

Thomas Hoepker - Coney Island beach, Brooklyn, USA, 1983

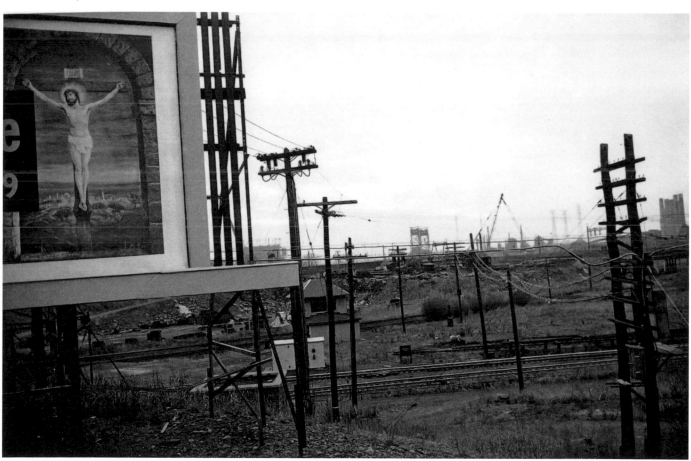

Bruce Davidson - New Jersey, USA, 1965

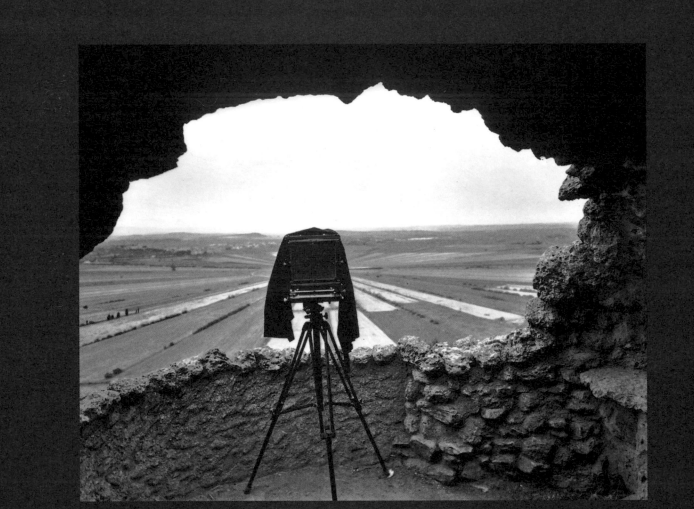

Raymond Depardon - Lake Montady, France, 1992

-3-
Reinvented Landscapes

The eye of the photographer catches the visual signs and messages offered to him by the modern world which is busy creating and destroying itself. He has given these indicators substance and shape. The material and debris of industry have become shapes and inorganic sculptures, and the labyrinth of our roads, sidewalks and streets an ornamental geometrical pattern, while the sudden appearance of people and objects foreign to the layout of the landscape becomes an integral part of the design.

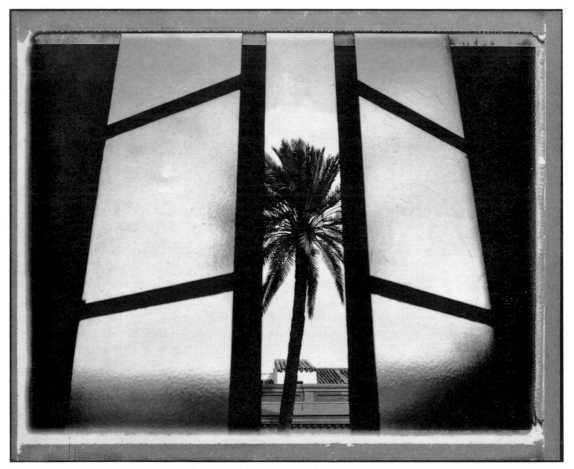

Gueorgui Pinkhassov - Seville, Spain, 1993

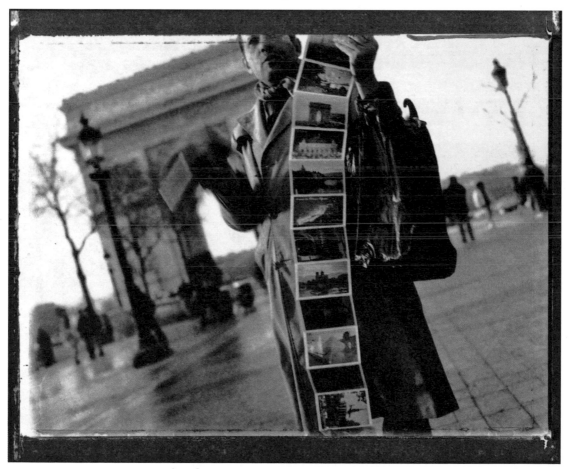

Jean Gaumy - Champs Elysées, Paris, France, 1996

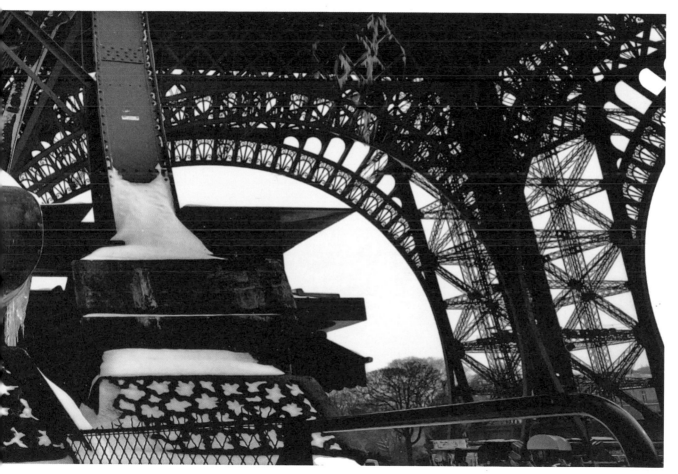

Josef Koudelka - Eiffel Tower, Paris, France, 1986

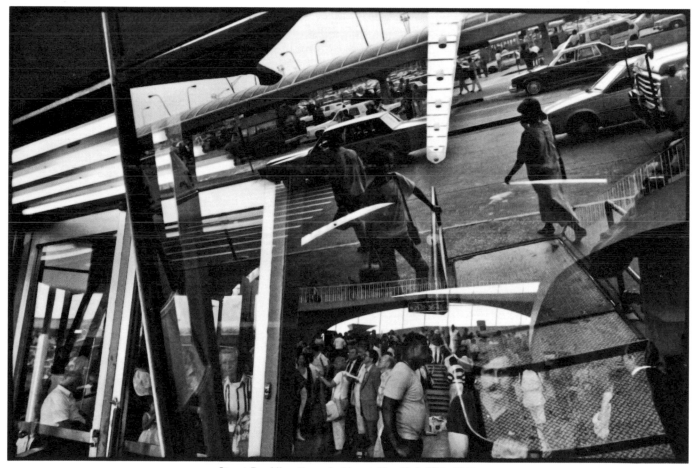

Stuart Franklin - Kennedy Airport, New York, USA, 1987

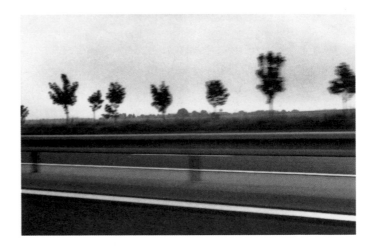

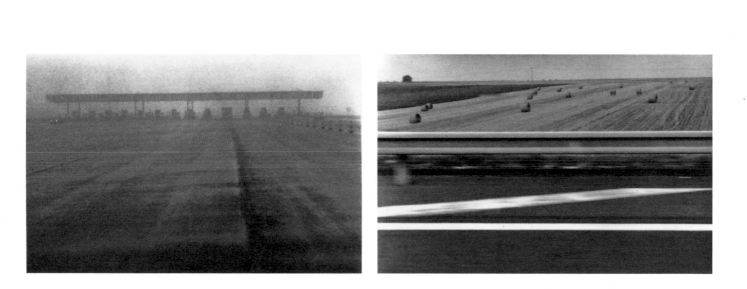

Patrick Zachmann - Motorways, France, 1982

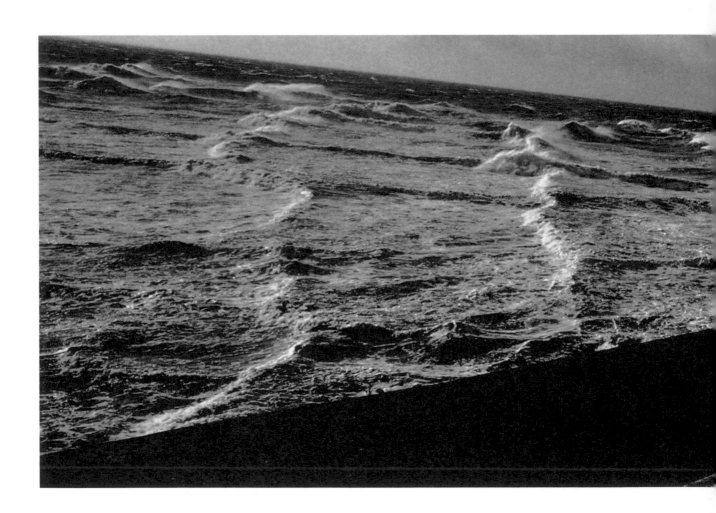

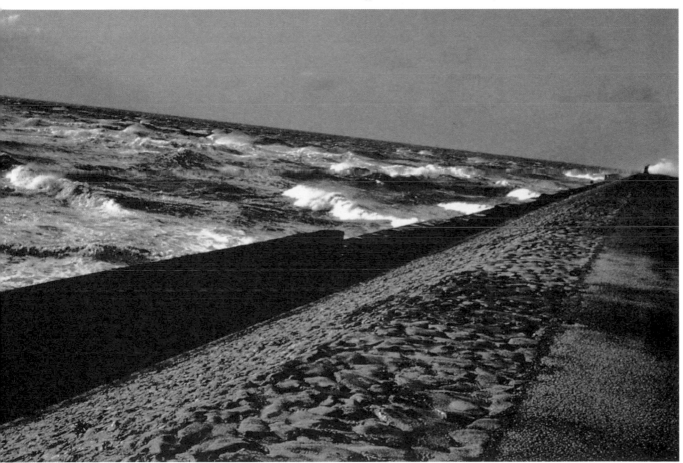

Josef Koudelka - Sea wall at Boulogne-sur-mer, France, 1988

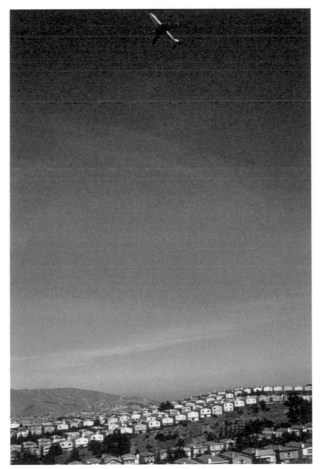

Eve Arnold - Daly City, California, USA, 1984

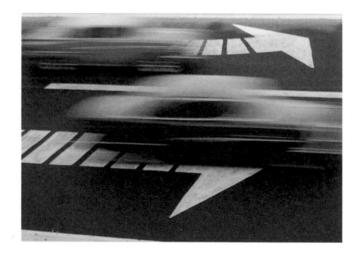

Ernst Haas - Mexico City, Mexico, 1963

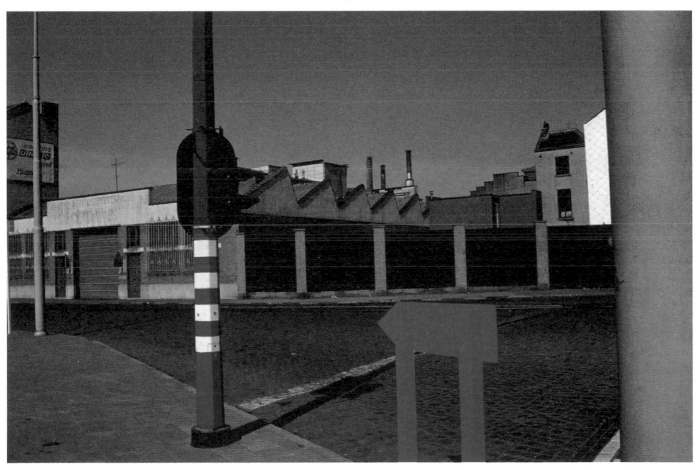

Harry Gruyaert - Brussels, Belgium, 1980

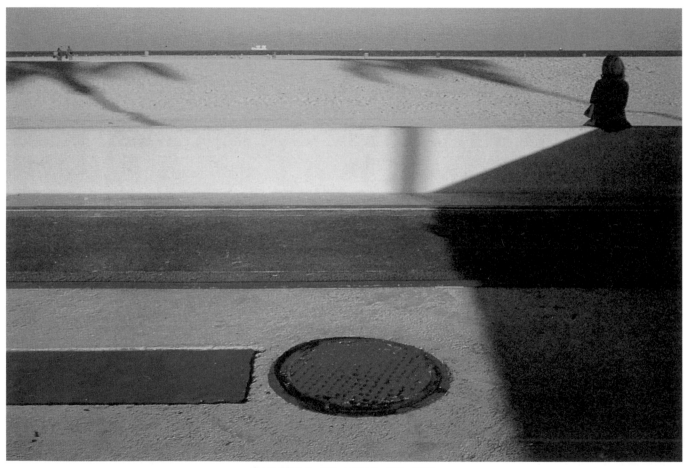

Costa Manos - Miami Beach, USA, 1982

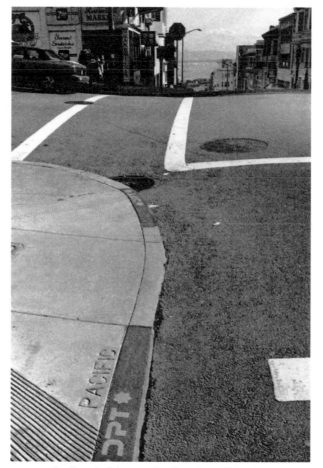

Ferdinando Scianna - San Francisco, USA, 1996

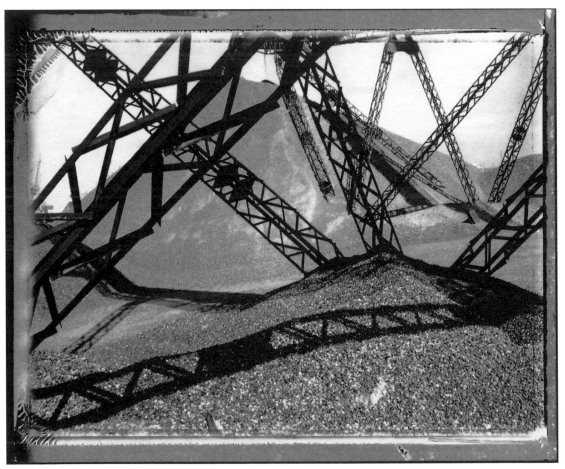

Jean Gaumy - Le Havre harbour, France, 1994

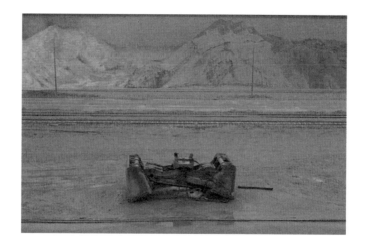

Harry Gruyaert - Ore storage depot, Sollac, Dunkirk, France, 1988

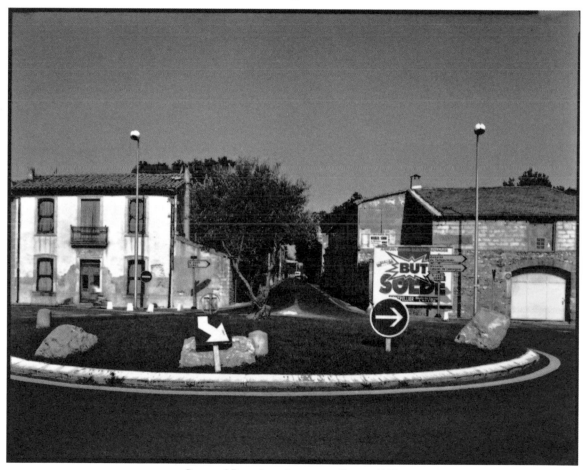

Raymond Depardon - Lansargues, France, 1993

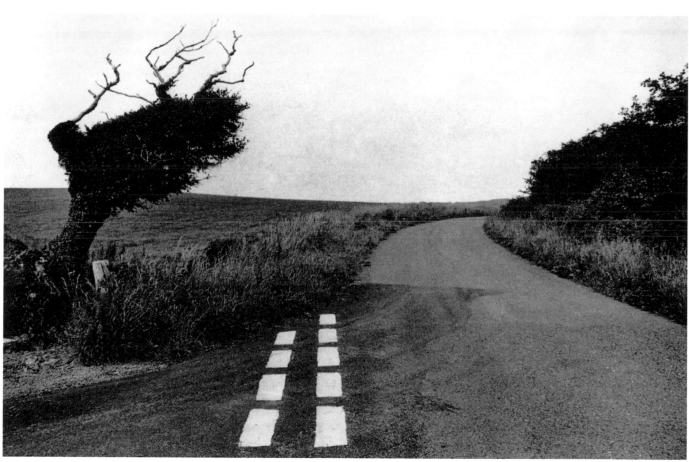

Josef Koudelka - England, 1978

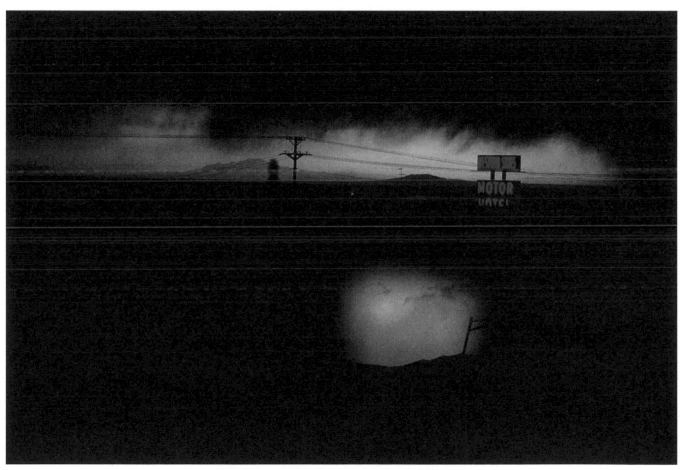

Ernst Haas - Western Skies Motel, Colorado, USA, 1978

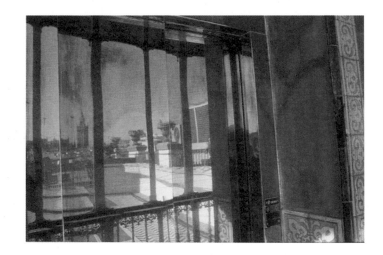

Gueorgui Pinkhassov - Seville, Spain, 1993

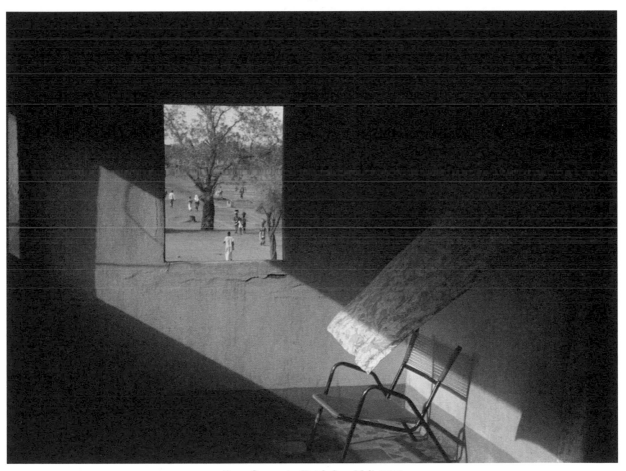

Harry Gruyaert - Hotel, Gao, Mali, 1988

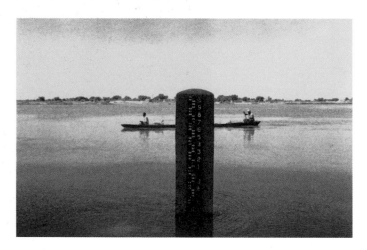

John Vink - Flood marker post, Tillabery, Niger, 1985

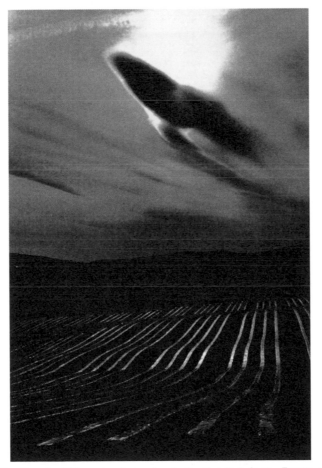

Martine Franck - Melons growing under plastic, Cereste, Luberon, France, 1976

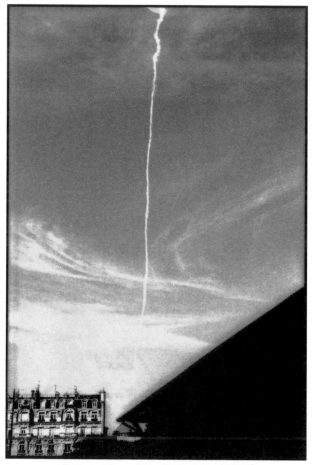

Raymond Depardon - Paris, France, 1984

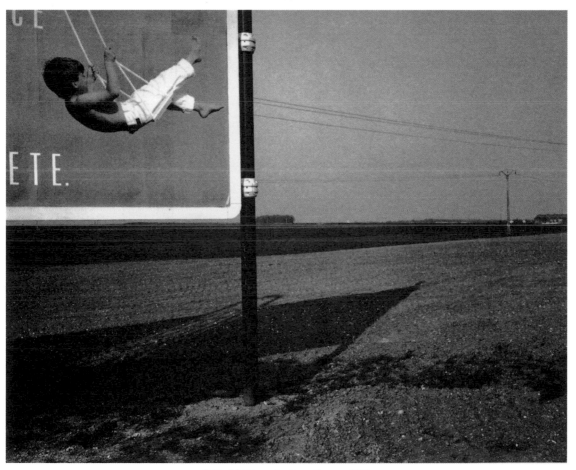

Peter Marlow - Amiens, France, 1991

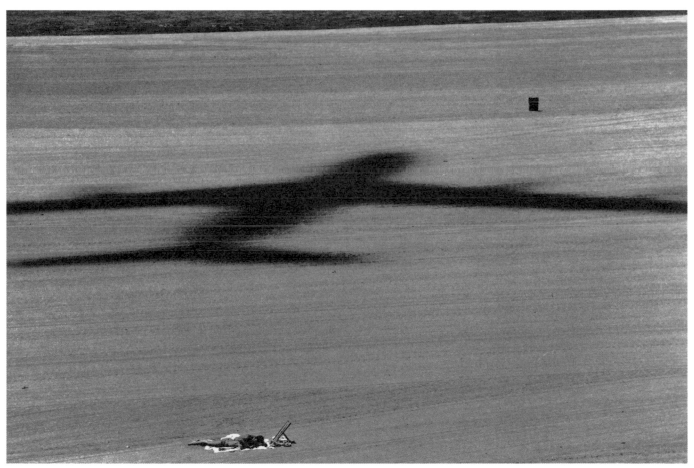

Dennis Stock - Playa del Rey, Southern California, USA, 1968

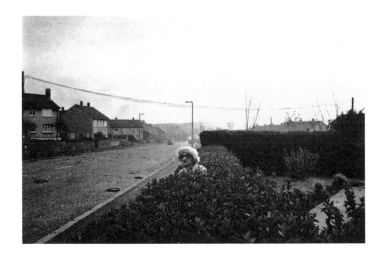

Gilles Peress - Belfast, Northern Ireland, 1981

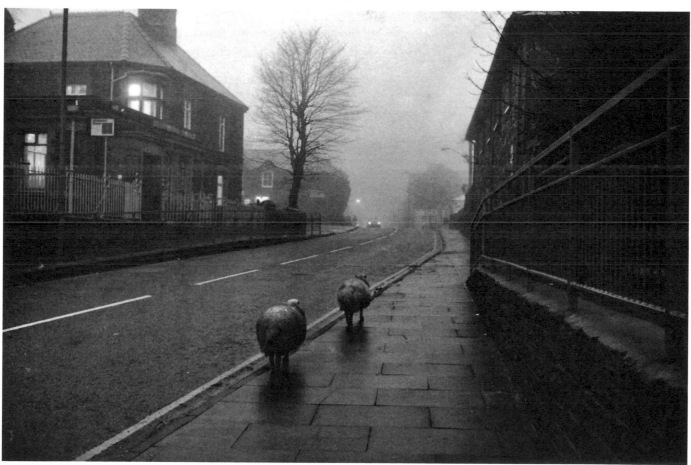

Peter Marlow - Blaennau Festiniog, Wales, 1986

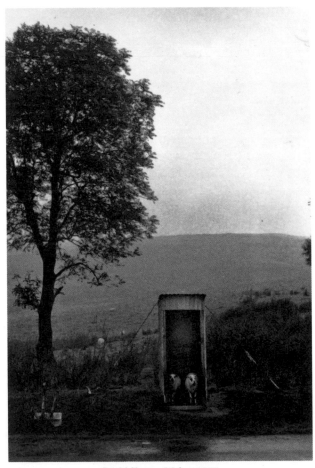

David Hurn - Wales, 1973

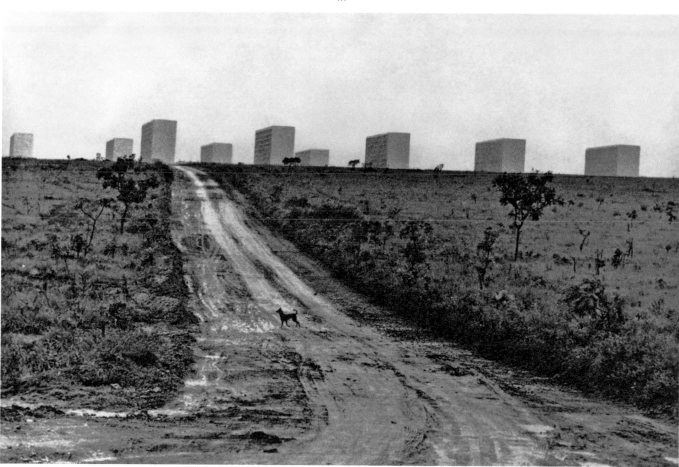

Elliott Erwitt - Brasilia, Brazil, 1961

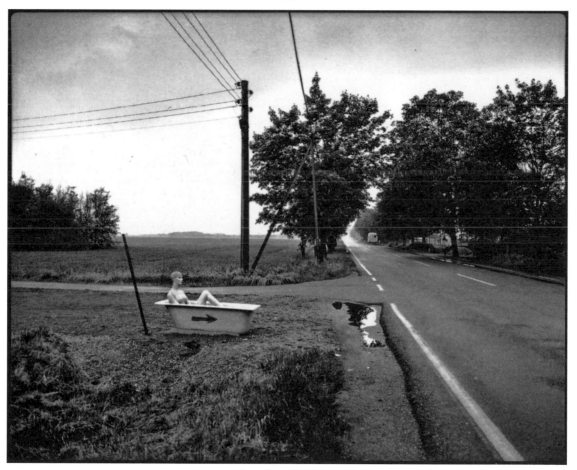

Raymond Depardon - East Germany, 1990

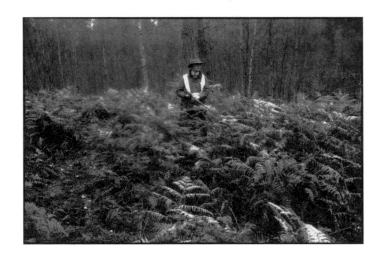

Richard Kalvar - France, 1996

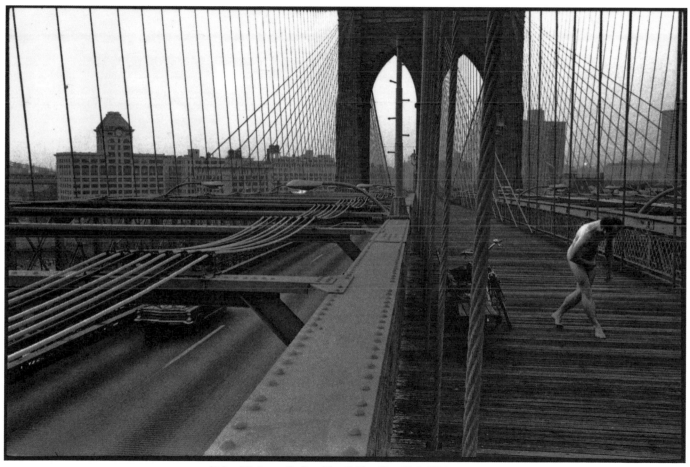

Richard Kalvar - On Brooklyn Bridge, New York, USA, 1969

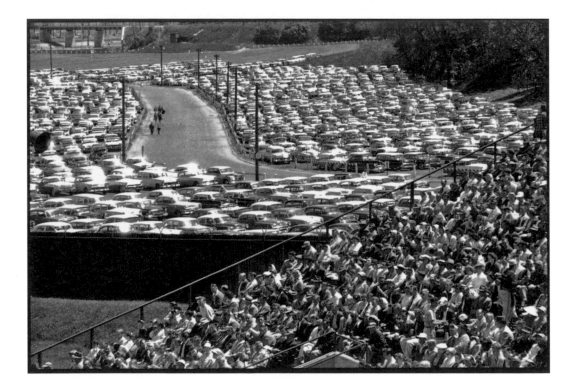

Henri Cartier-Bresson - Baseball match, Milwaukee, Wisconsin, USA, 1957

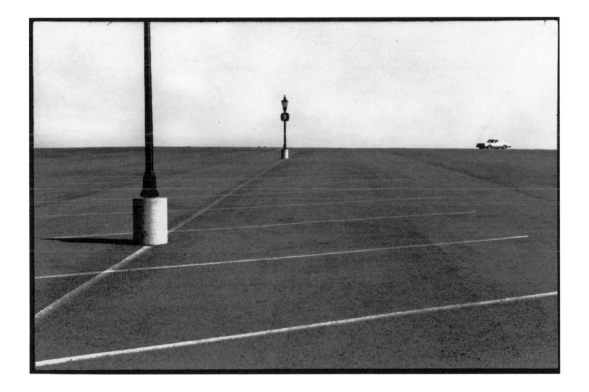

Raymond Depardon - Sun City, Arizona, USA, 1982

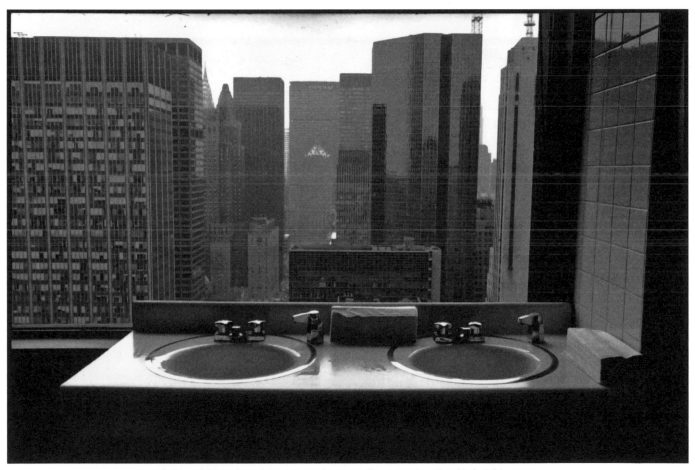

Raymond Depardon - Women's washroom at Geo magazine, New York, USA, 1981

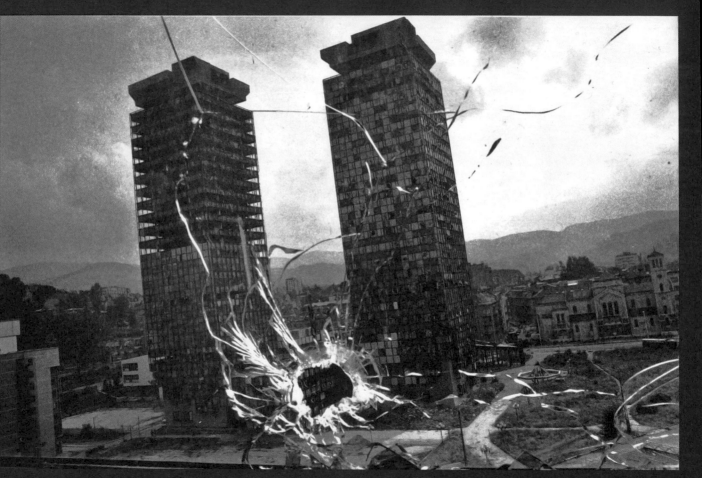

Gilles Peress - Sarajevo, Bosnia, 1993

-4-
Landscapes of War

Magnum was born out of war, and has remained a witness to conflict during fifty years. The photographer stops in the silence that precedes or follows battle, and uncovers its tracks. War, inscribed in the landscape, needs space to mark out its conquests. In its turn it creates a landscape: absolute devastation waged by the conqueror over the vanquished, displaced frontiers, migrations of peoples. The ephemeral landscape of war becomes a place of remembrance, a building ground for peace.

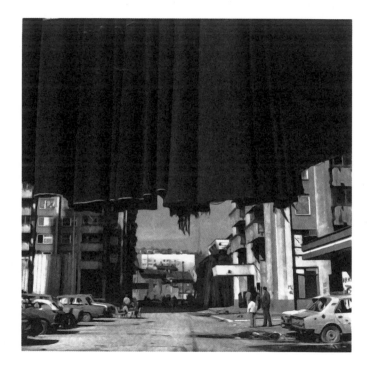

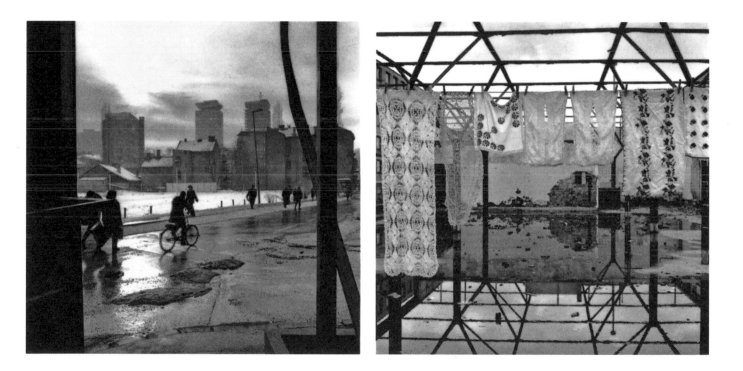

Paul Lowe - Sarajevo, Bosnia, 1994

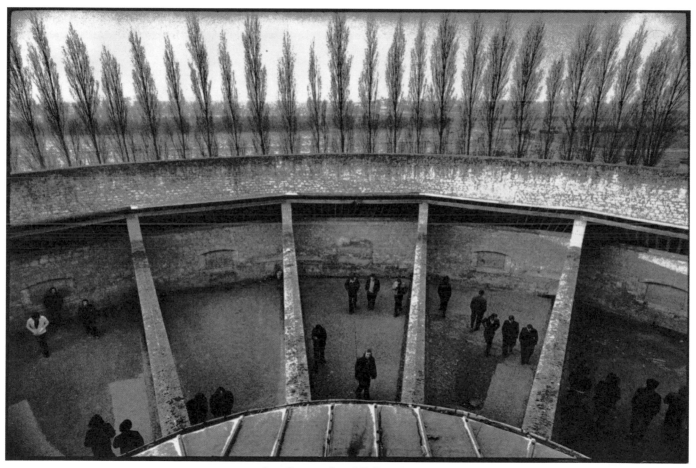

Jean Gaumy - Caen jail, France, 1976

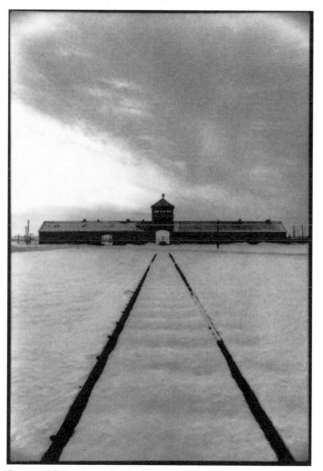

Raymond Depardon - Auschwitz concentration camp, Poland, 1979

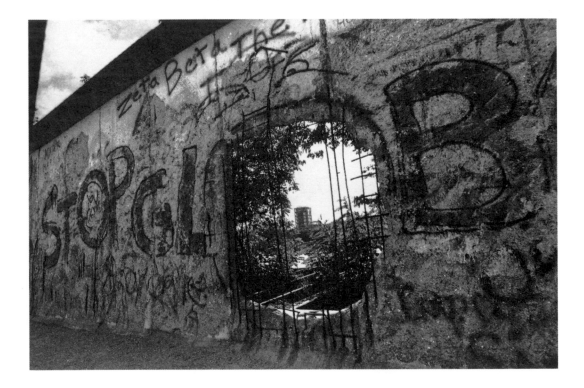

Ferdinando Scianna - The Berlin Wall, Germany, 1992

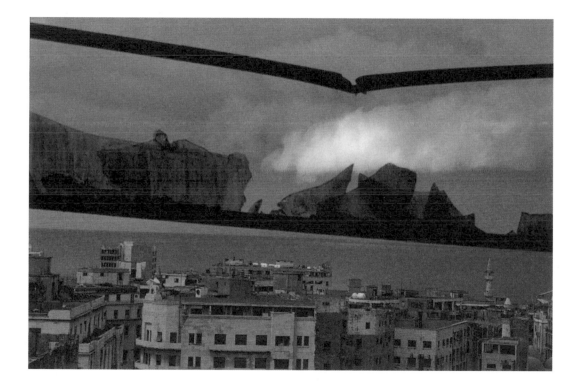

René Burri - View from the Azarieh Building, Beirut, Lebanon, 1991

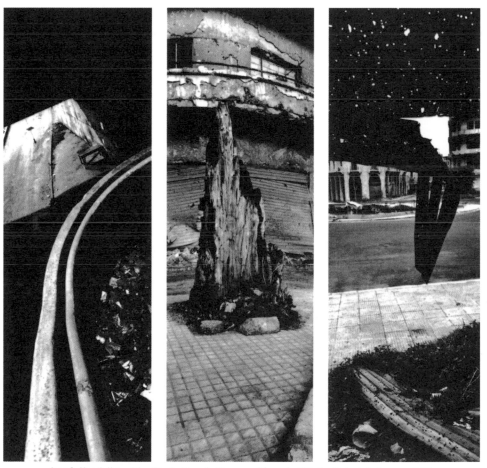

Josef Koudelka - The Ring - Rue de Damas - Place de l'Etoile, Beirut, Lebanon, 1991

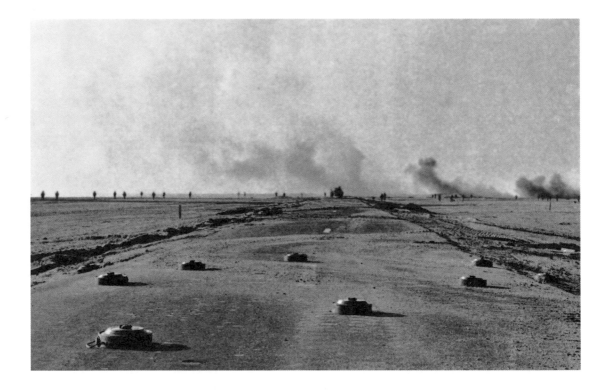

Micha Bar-Am - Yom Kippur War, Sinai, 1973

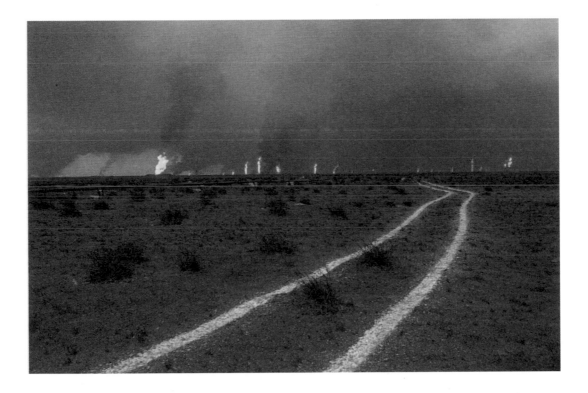

Bruno Barbey - Gulf War, Kuwait, 1991

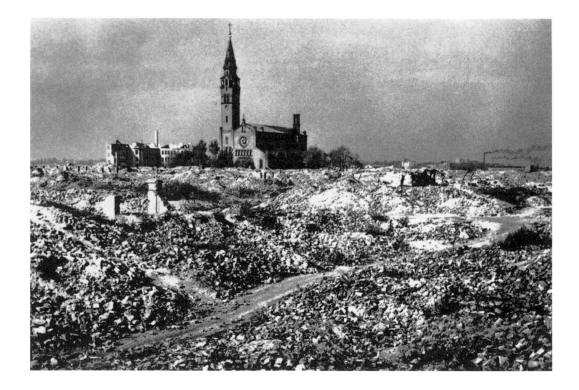

Robert Capa - Warsaw, Poland, 1945

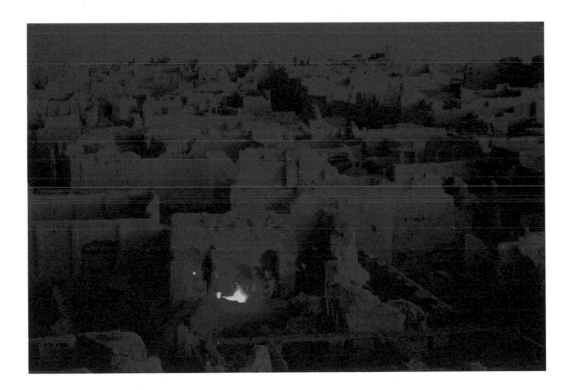

Steve McCurry - Family in their destroyed neighbourhood, Herat, Afghanistan, 1993

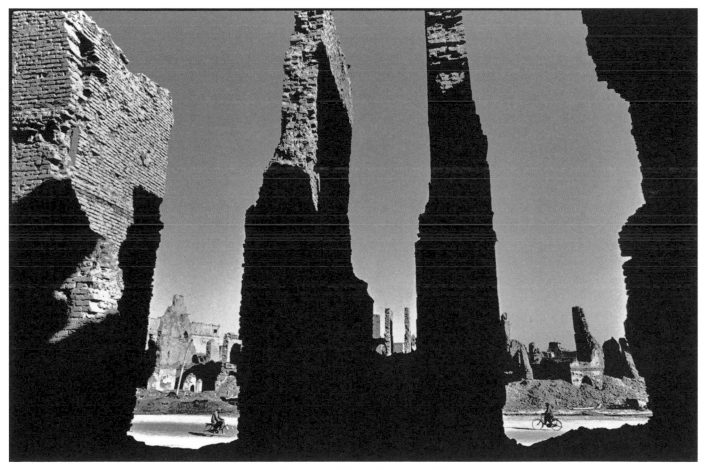

James Nachtwey - Kabul, Afghanistan, 1996

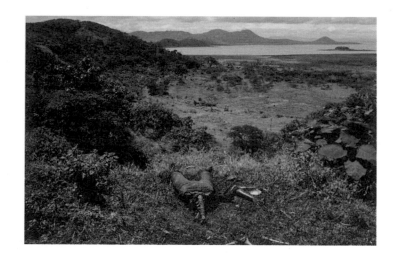

Susan Meiselas - Cuesta del Plomo, Managua, Nicaragua, 1978

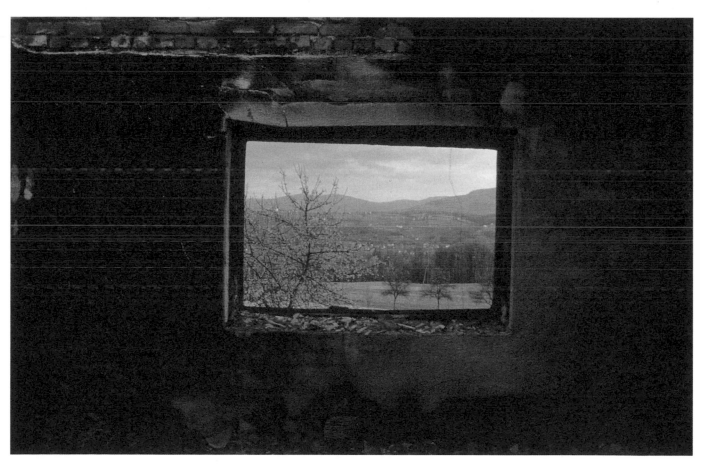

Luc Delahaye - Ahmici, central Bosnia, 1993

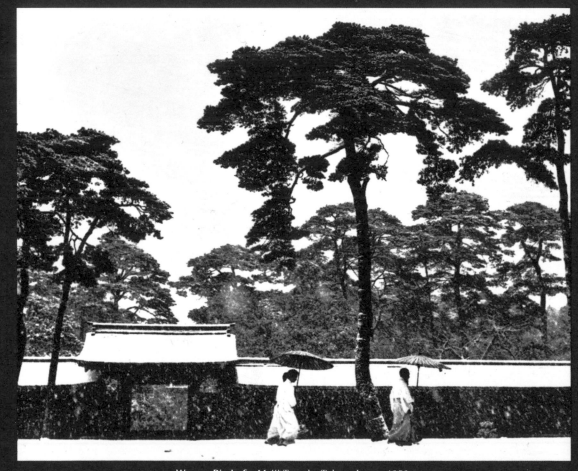

Werner Bischof - Meiji Temple, Tokyo, Japan, 1952

-5-
Man, Protagonist in the Landscape

We should not see the landscape only as a pageant, with man cast in the role of mere spectator or extra. We must not forget that man is a protagonist in the landscape: it is his territory, the product of his work and his journeying. He stamps himself upon it, and each enterprise of his history, agricultural, economic or ideological, carves its trace. This appropriation, sometimes collective, sometimes individual, produces dislocation or utopia, anxiety or harmony.

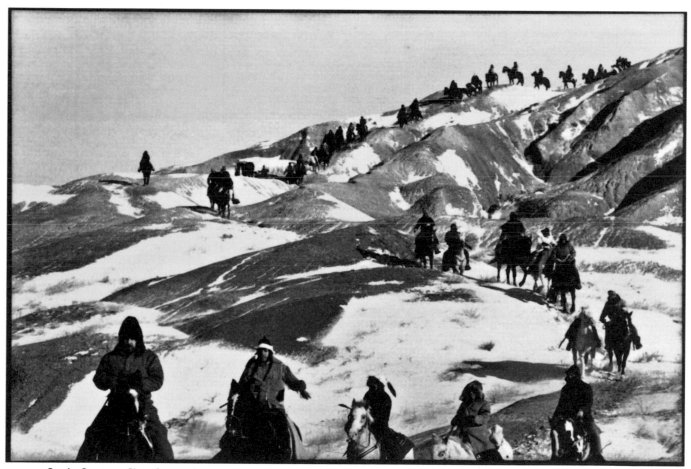

Guy Le Querrec - Sioux horse riders crossing Big Foot Pass in memory of the massacre at Wounded Knee, South Dakota, USA, 1990

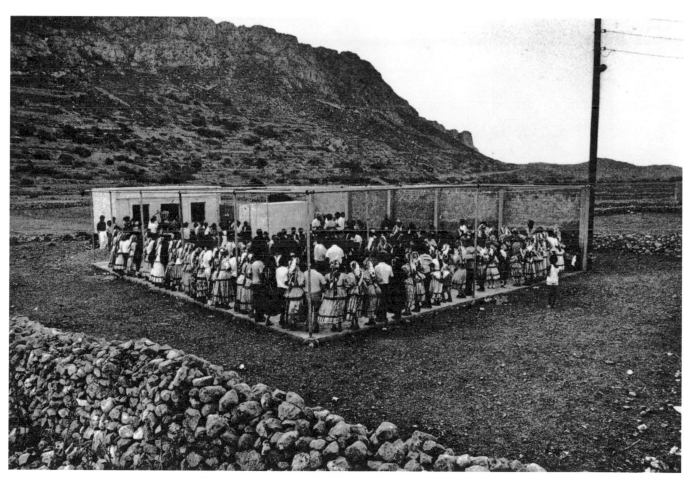

Nikos Economopoulos - Island festival, Karpathos, Greece, 1989

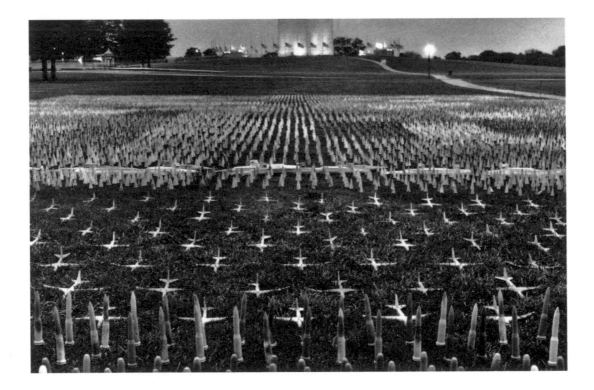

Erich Hartmann - Antimilitary protest at Washington Monument, Washington DC, USA, 1987

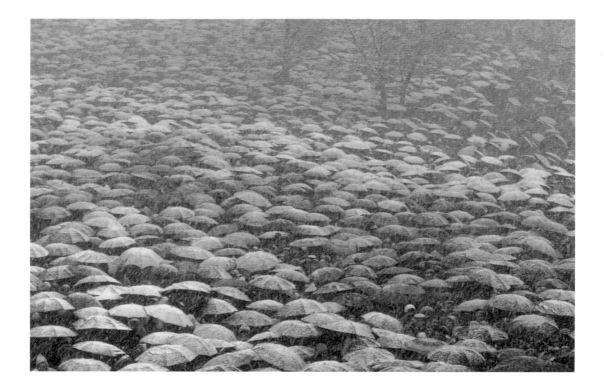

Bruno Barbey - Pilgrimage, Kalwaria, Poland, 1981

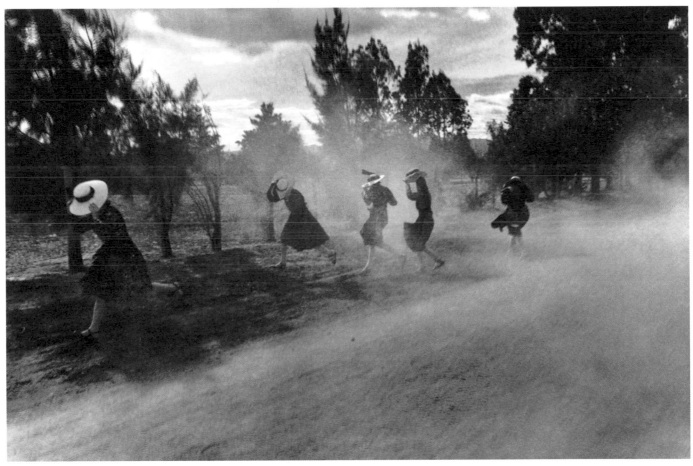

Larry Towell - Menntonite community, Mexico, 1994

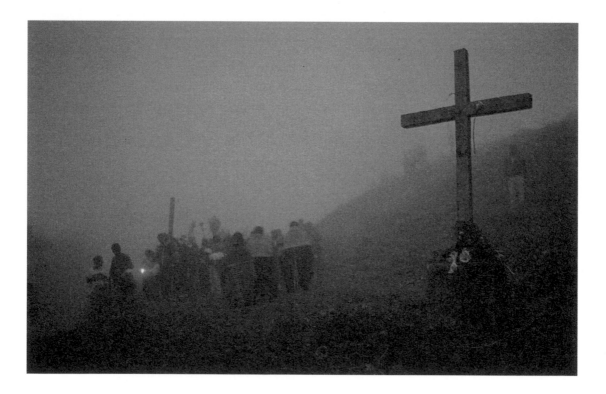

David Alan Harvey - Holy Week, Oaxaca, Mexico, 1995

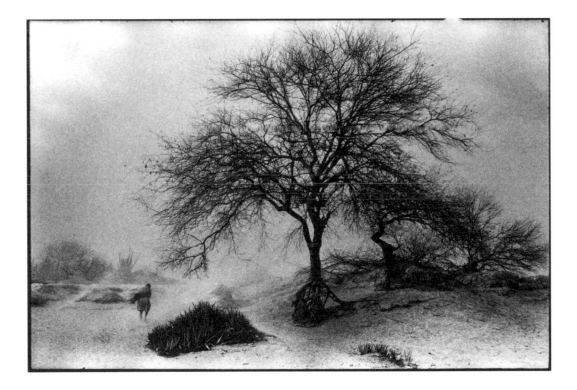

Abbas - Oapan, Mexico, 1985

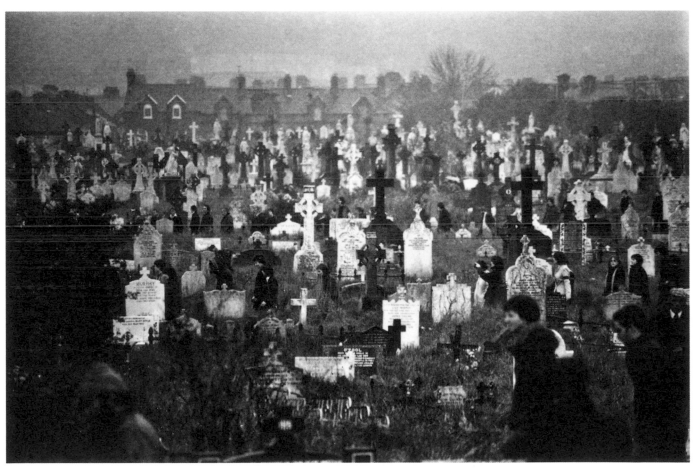

Gilles Peress - Funeral of Bobby Sands, Milltown Cemetery, Belfast, Northern Ireland, 1981

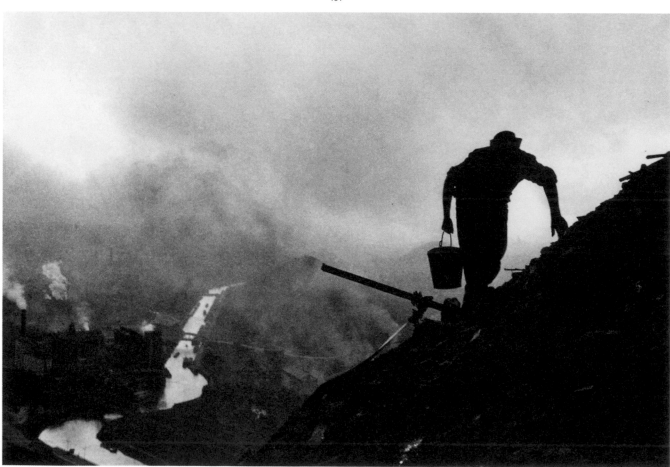

Leonard Freed - Terril, Charleroi, Belgium, 1977

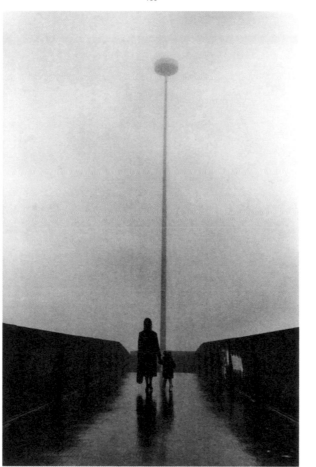

Peter Marlow - Netherley, Liverpool, England, 1992

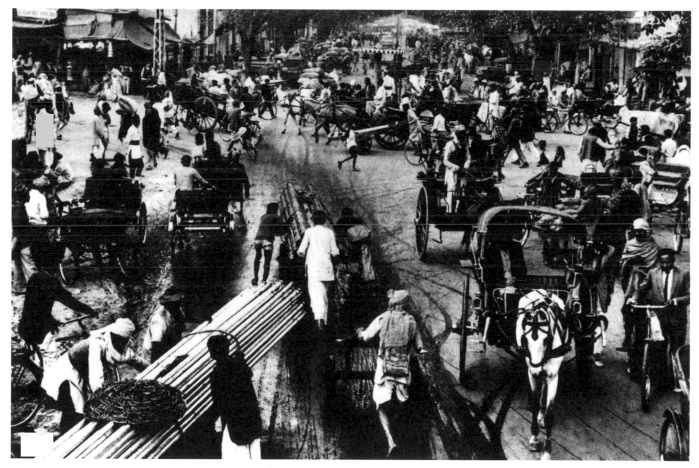

Raghu Rai - Chawri Bazaar, Old Delhi, India, 1972

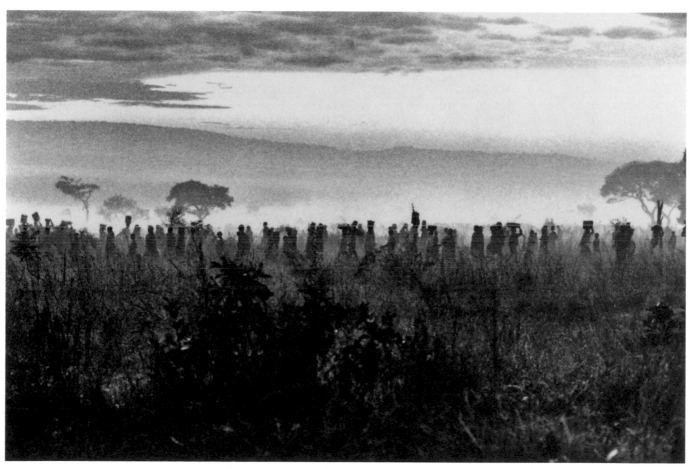

Gilles Peress - Refugees fetching water, Banako, Tanzania, 1994

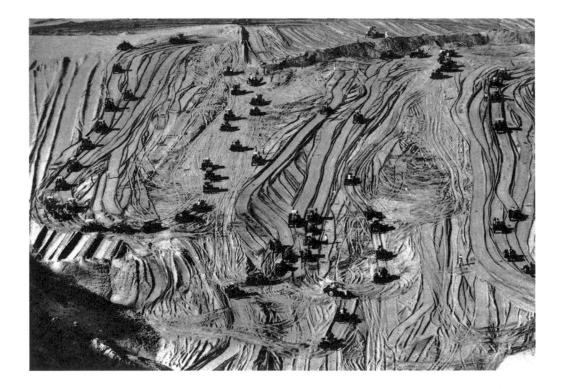

George Rodger - Tractors flattening a hill near Delhi, India, 1977

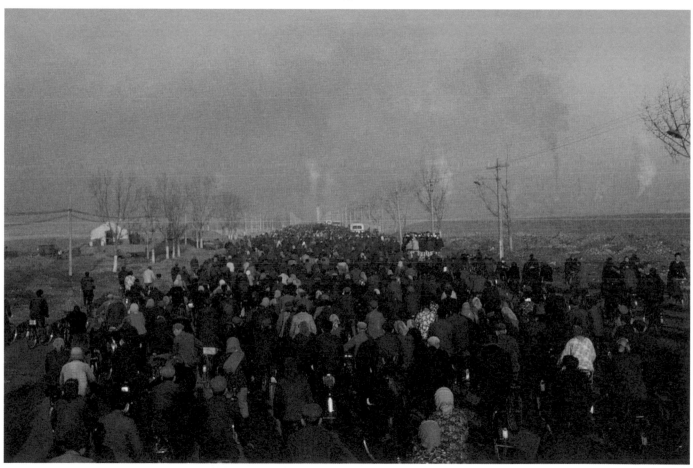

Hiroji Kubota - Workers going to Baotou, Bangtie Road, China, 1978

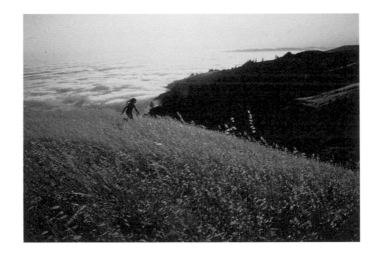

Paul Fusco - California, USA, 1969

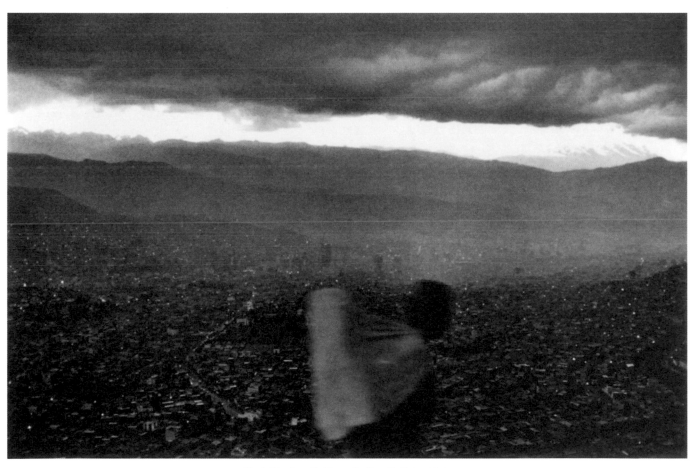

Chris Steele – Perkins - La Paz, Bolivia, 1984

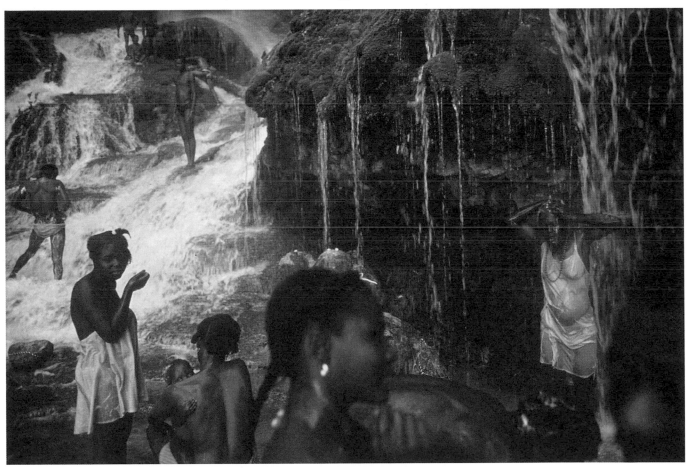

Alex Webb - 'Saut d'Eau' pilgrimage, Haiti, 1989

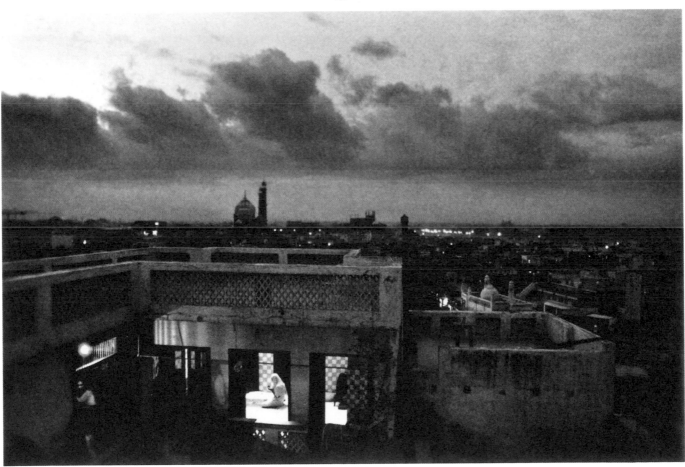

Raghu Rai - Delhi, India, 1975

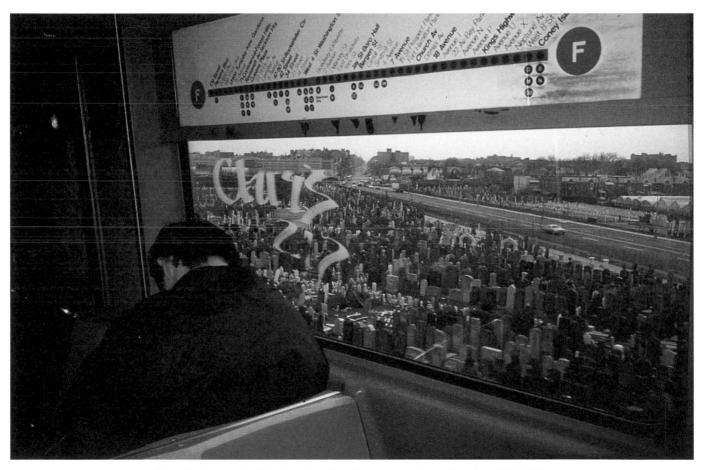

Bruce Davidson - Brooklyn Cemetery from the elevated subway, New York, USA, 1982

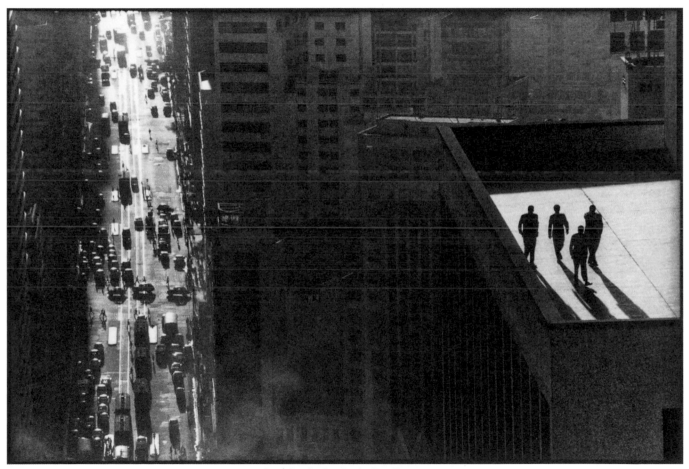

René Burri - Sao Paulo, Brazil, 1960

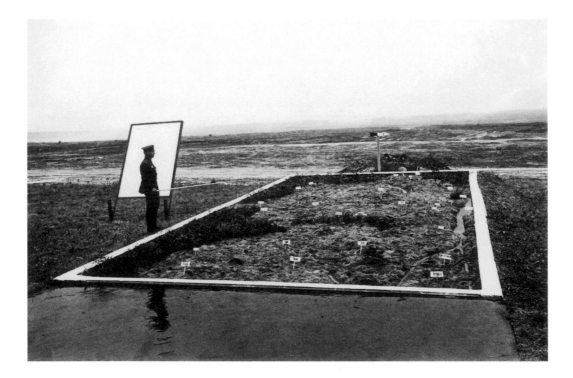

Elliott Erwitt - Simulation of a nuclear attack on a miniature battlefieid
during the visit of General de Gaulle to the USSR, 1966

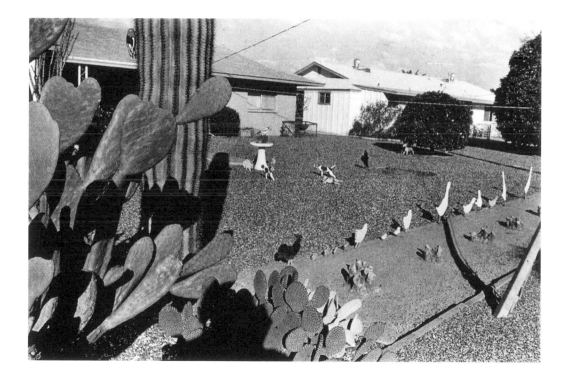

David Hurn - Phoenix, Arizona, USA, 1980

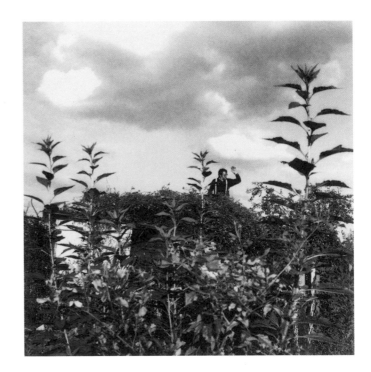

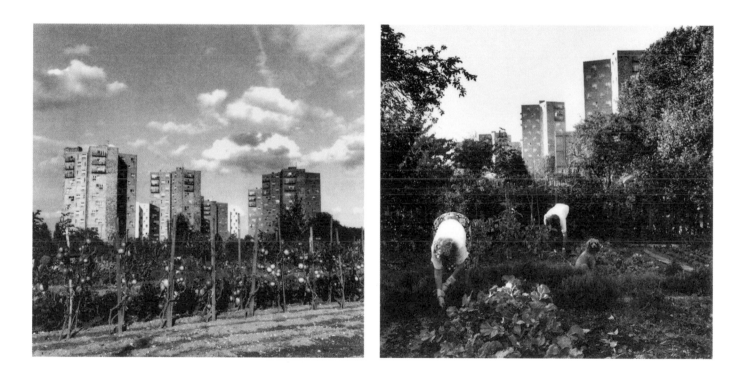

Patrick Zachmann - Allotments, Seine Saint-Denis, France, 1994

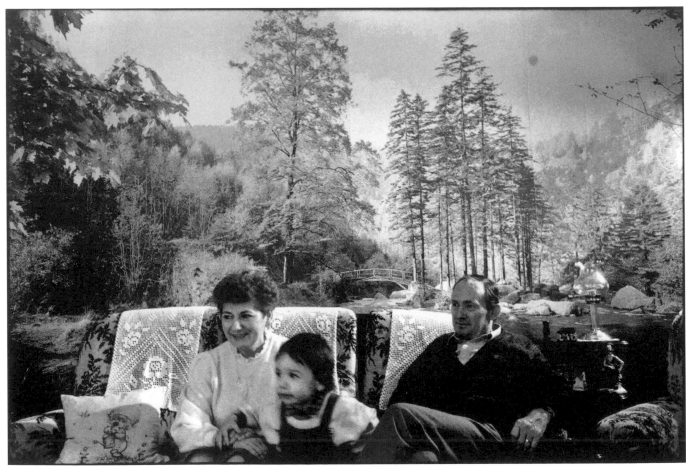

Patrick Zachmann - Villiers-le-Bel, France, 1989

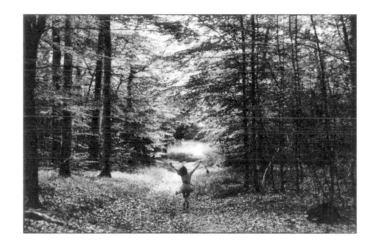

Raymond Depardon - Fontainebleau Forest, France, 1985

The Phenomenon of Landscape

Henri Peretz

After Eve centuries of painting, a century and a half of photographs, half a century of mass tourism, twenty years of questioning the effects of industrialization and de-industrialization on the environment, and a couple of years of virtual reality - where have we arrived with regard to landscape? The beauty and the charm of traditional scenery are a source of great joy for the beholder. The power and the brutality of modern design are a source of anxiety and astonishment. A fashion for albums, postcards and glossy magazines has allowed photographers to distribute a selection of their work to lovers of landscape. Even in the age of mass tourism photographers can still excite a taste for travel, for contemplation or rebellion. To create a landscape requires a photographer to have both a distance from and a particular rapport with the times in which he lives. The photographers of Magnum, more authors than reporters, have played an exemplary role in this respect.

Landscape as a Point of View

Certain cultures are ignorant of the very word landscape', while others, like the European culture, use the term constantly and ambiguously. The landscape is at one

and the same time an object and a representation. It is an actual place that we may traverse or alter, as well as the personal viewpoint of an artist or artisan. Landscape is no longer characterized by wild or unspoiled nature, for man has stamped his mark upon it: deforestation, intensive farming, urbanization, communication lines, electrification, industrial wastelands, battlefields or leisure parks.

Western culture, along with other cultures, notably the Japanese, has elaborated a methodology for the perception and representation of landscape: the invention of perspective in the Renaissance, the development in the seventeenth centuiy of urban and agricultural landscapes with low horizons merging earth and water, the explosion of photography in the nineteenth century, examining unknown immensities in exact and intimate detail.

Painters believed they had found a response to this challenge, which has lasted now for more than a centuiy: the Impressionists working in the open air in town and countryside captured the quality of light; then Cezanne constructed his geometric space, which Mondrian reduced to pure abstract forms. Today, real or fictitious panoramas capture our attention on multiple screens. Despite these metamorphoses, the eye can still recognize landscape by its constant traits. Whether seen from above or below, perception employs a frame, real or imaginary, a window through which the outside world arranges itself in strata - the foreground close and clear, followed by the middle ground ever more elongated and ever vaguer, until in the background all geometric lines converge. Every landscape grabs us and draws us into its depth. And man is only an implicit spectator, who generally plays a minor role: an aid to measure scale or simply an extra serving the drama.

A Supreme Photographic Genre

Landscape is the genre which, more than any other, sets in competition the simple viewer, the painter, the amateur and professional photographer. Each one wishes to recall a personal vision of this collective spectacle. For a long time, the photographer has permitted millions of viewers to discover spectacular landscapes which they would never have been able to see or photograph themselves. The most widespread and common vehicle for these discoveries was the often anonymous postcard.

But from the nineteenth century to our own time, photographers have, above all, been charged with the task of providing exceptional testimony from diverse projects: the exploration of unknown lands, the construction of great works, the state of affairs in various regions; arousing in some the urge for tourist travel, and satisfying in others the pleasures of contemplation. For other photographers landscape was a more personal project, resulting from a chance encounter or from contemplation of the arena of events. Their point of view always offers a particular outlook on what others may not always perceive as landscape.

Magnum and Landscape

Created in 1947 to proclaim autonomy for photographers, some of whom had witnessed the horror of the Second World War, the Magnum agency has been present during fifty years in all the places where significant events of our time have taken place: wars, rebellions, urbanization, industrialization, famine and the daily life of peoples on every corner of the earth. Magnum photographers have always wanted

to fulfil two ambitions: to be present at each crucial moment in history as well as at every unchallenged episode of daily life, and to fix both in an elaborately constructed image. They have given witness to human diversity while remaining sympathetic to each subject.

Landscape, however, requires particular attention to the physical environment rather than to people. To suddenly see the landscape behind human events is to suspend one's interest in action and focus on its purely visual signs. Landscape photography is either the outcome of a specific project or the result of an unexpected encounter with surroundings observed for other reasons - a kind of reverie or sketchbook.

Some photographers have taken part in commissions, such as Datar's in the 1980s, with the aim of 'creating a new portrait of the region'. They have published in magazines and have even devoted entire books to certain landscapes: for instance Ernst Haas's *The Creation* (1971), Dennis Stock's *Brother Sum* (1973) and *Haiku Journey* (1974), or more recently Josef Koudelka's *Black triangle* (1994).

All have broken new ground, each of them has interpreted the world as a landscape bearing the revelatory stamp of their own distinctive vision. For behind each image one recognizes the irony, the accusation, the complicity or the search for a definitive personal style in an overcrowded genre. It is there we find true invention lies. These images will be seen in the future as both document and aesthetic portrayal. They will provoke the recurring question among historians, is this a statement on the condition of the world, or a particular view of a landscape?

Chronology of landscape photography

by Henri Peretz

1816: Invention of photography by Nicephore Niepce (1765-1833).

1851: The first Universal Exhibition at Crystal Palace in London presenting daguerreotypes, notably landscapes by the American Mathew Brady (1823-96). This Universal Exhibition encourages the latest developments in landscape photography. From 1854, following his project on historic monuments, Edouard Denis Baldus (1813-90) photographs historic monuments and scenery in the Auvergne and Midi in France. Several railway companies commission him to do so. A growing number of French photographers travel in the Alps and Pyrenees.

1850-1898: Coming back from a photographic project in Egypt, Francis Firth (1822-98) reclaims the ground of Roger Fenton (1819-69) and produces a series of picturesque and tranquil views of England. Start of the commercialization of photographic travel albums.

1863: The actual date of the first postcard. However, several decades elapse before technical improvements and postal regulations permit general usage.

1865-1872: Before the end of the American Civil War, which was much photographed, geological and geographical expeditions to the west of America employed the services of the best photographers. Timothy H. O'Sullivan (1840-82), Mathew Brady and William Hemy Jackson with big plate cameras then photograph spectacular landscapes, hitherto unknown, for instance those of what was to be Yellowstone Park.

1880: Stereoscopes employing a double image viewed through two eyepieces are sold to private individuals. They bestow depth to distant landscapes.

1886: The British railway companies organize photographic tours through the countiyside of Surrey.

1888: With the invention of the film roll camera by George Eastman, amateurs can photograph and develop film more easily.

1890: The first landscape postcard, depicting Davos in Switzerland, is posted on 30 December. A year later the second, showing Marseilles, is sent.

1890: Start of the magazine *National Geographic*, devoted to the photographic discovery of the world. In 1919 they publish the first colour photograph and in 1930 the first aerial photograph. Today they have a print run of 14 million copies, sold monthly in 170 countries.

1890-1914: The needle-sharp results produced by ever more sophisticated lenses upset the aesthetes of the Pictorialist movement. In order to resemble painting they try to soften their images. Commandant Puyo (1868-1933) is one of the best-known exponents of this movement.

1890-1930: Edward S. Curtis (1868-1954) realizes his project devoted to the North American Indian.

1923: After a pictorialist period and the photography of cities, Alfred Stieglitz (1864-1946) settles at Lake

to fulfil two ambitions: to be present at each crucial moment in history as well as at every unchallenged episode of daily life, and to fix both in an elaborately constructed image. They have given witness to human diversity while remaining sympathetic to each subject.

Landscape, however, requires particular attention to the physical environment rather than to people. To suddenly see the landscape behind human events is to suspend one's interest in action and focus on its purely visual signs. Landscape photography is either the outcome of a specific project or the result of an unexpected encounter with surroundings observed for other reasons - a kind of reverie or sketchbook.

Some photographers have taken part in commissions, such as Datar's in the 1980s, with the aim of 'creating a new portrait of the region'. They have published in magazines and have even devoted entire books to certain landscapes: for instance Ernst Haas's *The Creation* (1971), Dennis Stock's *Brother Sun* (1973) and *Haiku Journey* (1974), or more recently Josef Koudelka's *Black triangle* (1994).

All have broken new ground, each of them has interpreted the world as a landscape bearing the revelatory stamp of their own distinctive vision. For behind each image one recognizes the irony, the accusation, the complicity or the search for a definitive personal style in an overcrowded genre. It is there we find true invention lies. These images will be seen in the future as both document and aesthetic portrayal. They will provoke the recurring question among historians, is this a statement on the condition of the world, or a particular view of a landscape?

Chronology of landscape photography

by Henri Peretz

1816: Invention of photography by Nicephore Niepce (1765-1833).

1851: The first Universal Exhibition at Crystal Palace in London presenting daguerreotypes, notably landscapes by the American Mathew Brady (1823-96). This Universal Exhibition encourages the latest developments in landscape photography. From 1854, following his project on historic monuments, Edouard Denis Baldus (1813-90) photographs historic monuments and scenery in the Auvergne and Midi in France. Several railway companies commission him to do so. A growing number of French photographers travel in the Alps and Pyrenees.

1850-1898: Coming back from a photographic project in Egypt, Francis Firth (1822-98) reclaims the ground of Roger Fenton (1819-69) and produces a series of picturesque and tranquil views of England. Start of the commercialization of photographic travel albums.

1863: The actual date of the first postcard. However, several decades elapse before technical improvements and postal regulations permit general usage.

1865-1872: Before the end of the American Civil War, which was much photographed, geological and geographical expeditions to the west of America employed the services of the best photographers. Timothy H. O'Sullivan (1840-82), Mathew Brady and William Hemy Jackson with big plate cameras then photograph spectacular landscapes, hitherto unknown, for instance those of what was to be Yellowstone Park.

1880: Stereoscopes employing a double image viewed through two eyepieces are sold to private individuals. They bestow depth to distant landscapes.

1886: The British railway companies organize photographic tours through the countiyside of Surrey.

1888: With the invention of the film roll camera by George Eastman, amateurs can photograph and develop film more easily.

1890: The first landscape postcard, depicting Davos in Switzerland, is posted on 30 December. A year later the second, showing Marseilles, is sent.

1890: Start of the magazine National Geographic, devoted to the photographic discovery of the world. In 1919 they publish the first colour photograph and in 1930 the first aerial photograph. Today they have a print run of 14 million copies, sold monthly in 170 countries.

1890-1914: The needle-sharp results produced by ever more sophisticated lenses upset the aesthetes of the Pictorialist movement. In order to resemble painting they try to soften their images. Commandant Puyo (1868-1933) is one of the best-known exponents of this movement.

1890-1930: Edward S. Curtis (1868-1954) realizes his project devoted to the North American Indian.

1923: After a pictorialist period and the photography of cities, Alfred Stieglitz (1864-1946) settles at Lake

George in up-state New York. It is here that he starts the famous series 'Equivalences'.

1924: Launch of the 35 millimetre Leica, the first really lightweight camera.

1927: Ansel Adams (1920-84) publishes 'The Face of Half Dome', one of his first depictions of Yosemite Park. He is a member of the Sierra Club.

1928: Creation of the French magazine Vn, which will be replaced by Pans MafcTi.

1936: The administration of Roosevelt, as part of the New Deal, send photographers out to report on the crisis hitting town and countryside - The Farm Security Administration Project. Walker Evans (1903-75) and Dorothea Lange (1895-1965) engage in a new type of landscape photography, showing in their work traces of contemporary life such as advertising hoardings and street cars.

1947: Start of the Magnum Photo Agency by Robert Capa, Henri Cartier-Bresson, David Seymour, George Rodger and William and Rita Vandivert.

1955: Publication of *Americans* by Robert Frank.

1963: The advertising campaign of a smoking cowboy in a western American landscape is launched.

1964-1968: Bruno Barbey of Magnum publishes his series *Atlas de Voyages* with the publisher Rencontres.

1971: Ernst Haas (1921-86) of Magnum publishes *Creation* and *In America*

1975: The exhibition *New Topographics* opens in Rochester and marks a turning point in the nature of landscape photography; dissonant elements like pollution and anarchic constructions are dominant. Most famous exponent is Lewis Baltz.

1976: Start of the magazine *Geo* in Germany, today published in a print-run of 1.5 million and appearing in 5 countries.

1980: Inventory of the French landscape is done through a commission by Datar. Thirty photographers take part in this commission, amongst others Raymond Depardon and Josef Koudelka.

1980: The commission Second View starts in the US, contemporary photographers revisit the sites in the West that were covered by their nineteenth-century predecessors. Robert Adams publishes *From Missouri West*.

1981: The Museum of Modern Art in New York shows an exhibition of American landscape from its archives.

Subsequently: De-centralization, different urban and industrial reconstructions as well as a growing sense of responsibility for what is happening to the environment penetrate many of the commissions in which the Magnum photographers participate.

———

Commissions represented in this book:

Invitation au rivage, Conservatoire du Littoral et Fondation Gaz de france, p. 13

Incertain Pays, Centenaire de Maupassant, Ministére de la Culture et Ville de Fécamp, p. 39

La Somme, Conseil Général de la Somme avec la Maison de la Culture d'Amiens, pp. 44, 45 and 105.

Mission du Paysage, Ministére de l'Equipement avec le Conseil Général de l'Hérault, pp. 74 and 95.

Séville, Banesto Foundation, pp. 76 and 100.

Les Champs Elysées, Andersen Consulting, p. 77.

Mission photographique de la DATAR, pp. 78 and 79.

Mission Transmanche, Centre Régional de la Photographie Nord-Pas-de-Calais, pp. 84 and 85.

Port Autonome du Havre, p.92.

Regards d'acier, Sollac Dunkerque, p 93.

Allemagne de l'Est, Ministere de la Culture, p.113.

Farewell to Bosnia, Fondation de France, p. 120.

Beyrouth centre ville, Fondation Hariri, pp. 129 and 131.

Le Silence, Fondation de France and John Simon Guggenheim Foundation, p. 159.

Les jardins ouvriers, Conseil Général de Seine Saint-Denis, pp.174 and 175.

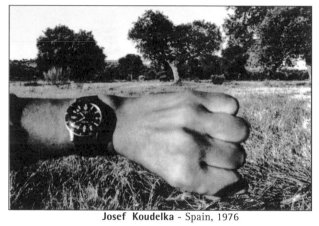

Josef Koudelka - Spain, 1976